SIDNEY GOODMAN

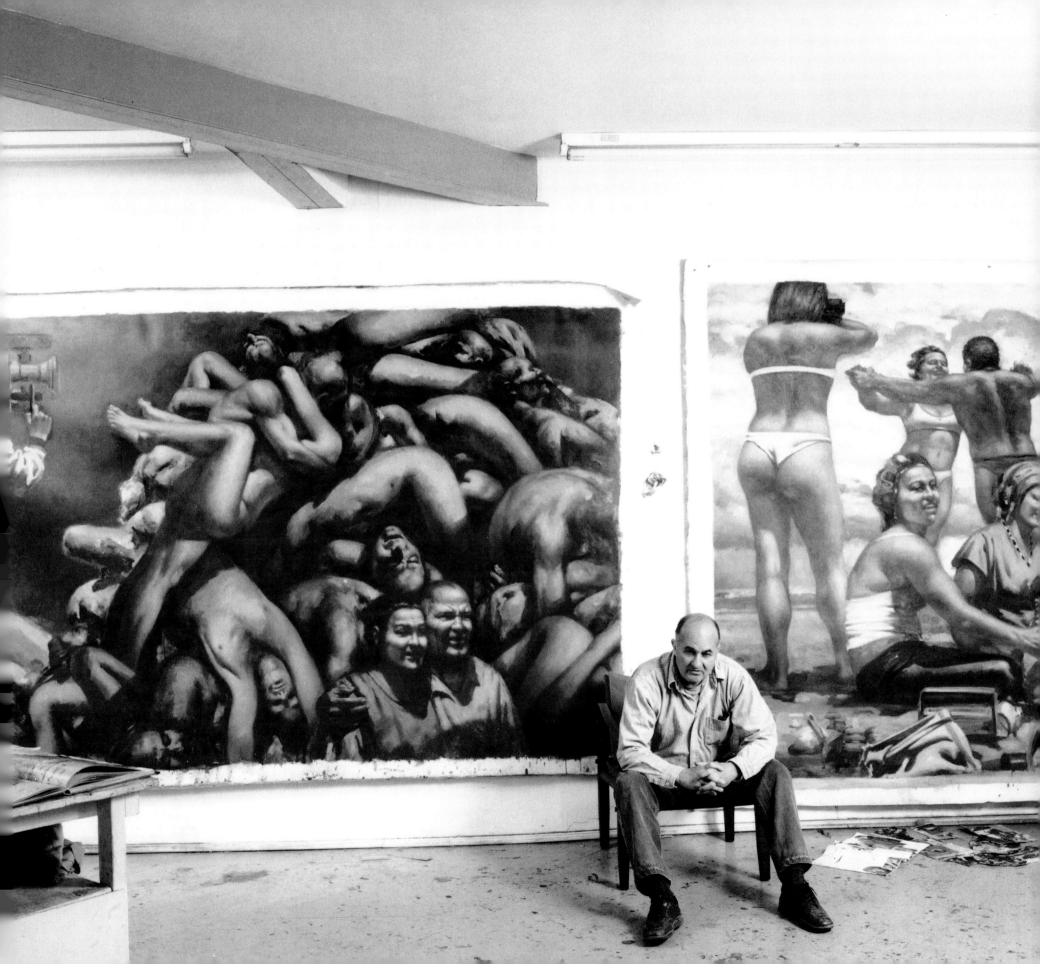

# Sidney Goodman

*Paintings and Drawings, 1959–95*

John B. Ravenal

Philadelphia Museum of Art

Published on the occasion of an exhibition at the
Philadelphia Museum of Art, February 11–March 31, 1996

The exhibition and catalogue are made possible in part by
grants from the National Endowment for the Arts,
The Pew Charitable Trusts, and The William Penn Foundation,
and by contributions from Mr. and Mrs. Frank H. Goodyear, Jr.,
Mr. and Mrs. David N. Pincus, Marion Stroud Swingle,
and anonymous donors.

Cover: Detail of *Free Fall* (plate 46)
Frontispiece: Sidney Goodman in his studio, April 1995

Editor: Sherry Babbitt
Designer: Anthony McCall Associates
Production Manager: Sandra M. Klimt
Printer: Litho Inc., Saint Paul, Minnesota

Produced by the Department of Publications
Philadelphia Museum of Art
2525 Pennsylvania Avenue
Philadelphia, Pennsylvania 19130

Printed and bound in the United States of America

Available through D.A.P./Distributed Art Publishers
636 Broadway, 12th Floor, New York, New York 10012
Telephone: (212) 473-5119   Fax: (212) 673-2887

Library of Congress Cataloging-in-Publication Data

Ravenal, John B.
    Sidney Goodman : paintings and drawings, 1959–95 / John B. Ravenal.
       p.   cm.
    Exhibition catalog.
    Includes bibliographical references and index.
    ISBN 0-87633-099-5 (alk. paper)
    1. Goodman, Sidney—Exhibitions. 1. Goodman, Sidney. 11. Title.
N6537.G634A4  1996
759.13—dc20                           95-50783
                                        CIP

# Contents

# Lenders to the Exhibition

Allentown Art Museum, Allentown, Pennsylvania

The Art Institute of Chicago

Richard and Donna Burnett

The Butler Institute of American Art, Youngstown, Ohio

Dr. Martin Cherkasky

Columbus Museum of Art, Columbus, Ohio

Jalane and Richard Davidson

Andrew and Ann Dintenfass

Terry Dintenfass, Inc., in association with Salander-O'Reilly Galleries, New York

Terry Dintenfass, Inc., in association with Salander-O'Reilly Galleries, New York, and The More Gallery, Inc., Philadelphia

Sidney Goodman

Frank and Betsy Goodyear

Malcolm Holzman

Nat and Georgia Kramer

Rodger LaPelle and Christine McGinnis

Dr. Thomas A. Mathews

The Metropolitan Museum of Art, New York

Museum of American Art of the Pennsylvania Academy of the Fine Arts, Philadelphia

Pennsylvania Convention Center Authority, Philadelphia

Philadelphia Coca-Cola Bottling Company

Philadelphia Museum of Art

Private collections (3)

Lynda and Stewart Resnick, The Franklin Mint, Franklin Center, Pennsylvania

Rose Art Museum, Brandeis University, Waltham, Massachusetts

Joseph D. and Janet M. Shein

Mr. and Mrs. John J. Turchi, Jr.

Virginia Museum of Fine Arts, Richmond

Whitney Museum of American Art, New York

Wichita Art Museum, Wichita, Kansas

# Foreword

In an American city with a particularly rich tradition of figurative painting that stretches back over almost three centuries to the founding of the Pennsylvania Academy of the Fine Arts in 1805 and then to the later decades of the eighteenth century, when Charles Willson Peale, together with numerous talented offspring, created a body of work notable for its careful observation of the world combined with a strong sense of the moral and educational purpose of art, Sidney Goodman joins a grand tradition yet gives it his own unmistakable stamp. Like so many American artists of his generation, his parents arrived as immigrants, and his work resonates with issues and anxieties shared with contemporary painters in many other parts of the globe. Toward the end of the twentieth century, Goodman's determined devotion to figuration over the past thirty-five years grows increasingly notable as other artists have shifted between diverse modes of working. Yet his art, as the present exhibition bears witness, is constantly evolving as it encompasses both his fascination with capturing the characteristic shapes, features, and gestures of humanity (whether drawn from his family and friends or from newspaper snapshots) and his drive to incorporate them into disturbing compositions that convey complex, even contradictory meanings.

The Philadelphia Museum of Art itself is deeply implicated in the city's artistic tradition, encompassing as it does major holdings of the work of Charles Willson Peale and Thomas Eakins, and having, for the first eighty-eight years of its existence, been linked with one of the most eminent of art schools, independent since 1964 and now known as the University of the Arts, where Goodman received his training in the 1950s. In its mission to serve international, national, and regional audiences alike, the Museum draws great satisfaction from an opportunity such as this to exhibit and publish the work of an artist whose roots are in Philadelphia and whose art has resonance for a wide contemporary public.

The exhibition was first mooted when Mark Rosenthal was serving as Curator of Twentieth-Century Art, warmly supported by Ann Temkin, now the Muriel and Philip Berman Curator of the department, and brought into being with characteristic enthusiasm and thoroughness by John Ravenal, Assistant Curator, who has worked closely with the artist in selecting the exhibition, and whose thoughtful text throws new light on Goodman's provocative and elusive imagery.

Many friends and admirers of Sidney Goodman's work have been unstintingly helpful, with loans, with reminiscences, and with support for this project, and we owe them heartfelt thanks. To Terry Dintenfass, for her energetic and enthusiastic help throughout the project, goes our warmest appreciation. We are enormously grateful to the artist not only for his good-humored patience in responding to every sort of question but for his assistance whenever needed. No project as ambitious as this one can be realized without financial support from a variety of sources, and we are heartened by the mix of private and public funding that the exhibition received. The Pew Charitable Trusts and The William Penn Foundation have been consistently generous in support of projects seeking to present and publish the best of this region's art, and the receipt of a substantial grant from the National Endowment for the Arts was particularly gratifying. Contributions have also come from an impressive array of friends of the Museum and of contemporary art, including Mr. and Mrs. Frank H. Goodyear, Jr., Mr. and Mrs. David N. Pincus, Marion Stroud Swingle, and anonymous donors.

No matter how large a museum may be, nor how comprehensive its collections of the art of the past, the importance for its audience of seeing contemporary work within its walls seems undeniable. Since making art is among the oldest of human activities, the presence of new work within a comprehensive museum such as this one reminds us vividly that the creative drive is irrepressible, and that every object on view, whether made yesterday or seven centuries ago, is shaped around a core of individual creativity. Sidney Goodman, fine painter, draftsman, and teacher that he is, assures us that the enterprise is as complex and profoundly human as ever, and we thank him for his example.

Anne d'Harnoncourt

The George D. Widener Director

# Acknowledgments

Organizing an exhibition and producing a catalogue involve the talents of a vast array of people, and I would like to thank those who participated most directly in these projects. First and foremost, it has been immensely rewarding to work closely with Sidney Goodman over the last four years. I have benefited from his many thoughtful suggestions and appreciated his friendly, accessible manner as well as the trust he placed in me to shape these presentations of his work.

We are enormously grateful to the lenders of paintings and drawings by Goodman. They have been unanimously enthusiastic about this exhibition and exceedingly generous in parting with their works from their homes and public collections. To them we extend our deepest appreciation. I would also like to thank the many other individuals and institutions across the country who graciously allowed me access to works by Goodman in their collections and who aided with our research for the catalogue. Additional thanks are due to Michael Moses for his special efforts on behalf of the exhibition and publication.

Terry Dintenfass, Philippe Alexandre, and Marie Erskine at Terry Dintenfass, Inc., New York (now in association with Salander-O'Reilly Galleries), were unfailingly helpful. Charles More and Cherie Turchi at The More Gallery, Inc., Philadelphia, also provided much valuable assistance. The Archives of American Art of the Smithsonian Institution in Washington, D.C., kindly granted permission to publish excerpts from Marina Pacini's interview with the artist.

For their guidance with organizing the exhibition and for their valuable comments on the catalogue manuscript, I am indebted to Anne d'Harnoncourt, Director of the Philadelphia Museum of Art, and Ann Temkin, Curator of Twentieth-Century Art. Virginia Pye also provided helpful suggestions on the catalogue essay. Sherry Babbitt merits special appreciation for carefully editing the entire publication, and Sandra Klimt deserves high praise for deftly managing the catalogue production. I am also grateful to Anthony McCall and John Bernstein for their handsome book design.

Many other individuals at the Museum contributed to the organization of the exhibition, in particular: Suzanne F. Wells and Elizabeth S. Lawton in Special Exhibitions; Irene Taurins, Elie-Anne Santine Chevrier, Nancy Russell, and Laney B. Waddel in the Office of the Registrar; Suzanne Penn, Nancy Ash, and Faith H. Zieske in Conservation; Mari M. Jones in the Office of the Director; Graydon Wood and Lynn Rosenthal in Photography; Michael MacFeat, Martha Masiello, and their colleagues in Packing and Art Handling; and Gary R. Hiatt in the Print Department. Many thanks are also due to my interns and research assistants over the course of this project, including Tom Hartman and Tanya Pohrt, and especially Shannon Donovan and Waqas Wajahat.

JBR

# Sidney Goodman's Vision

by John B. Ravenal

Sidney Goodman is one of the preeminent contemporary American painters and draftsmen exploring the still fertile ground of art based on the human form. For over three decades the style that he has forged out of direct observation, creative imagination, and prolonged study of European and American masters has demonstrated the continuing vitality of figurative art. But Goodman's embrace of metaphor and the metaphysical has set his brand of figuration markedly apart from that of other major artists of his generation, including Philip Pearlstein, Alfred Leslie, and Alex Katz. Goodman has developed an approach that is perhaps best understood as allegorical, albeit a thoroughly contemporary version of this traditional manner not tied to mythological or biblical texts, but instead lodged in modern urban and suburban subject matter. Because the visible world provides the stimulus for Goodman's allusive inventions, the sometimes contradictory meanings of vision come into play: observation serves as the jumping-off point into a realm of visualization that often proves unsettling to familiar sight.

Like many contemporary figurative artists, Goodman initially also explored abstract painting, which reflects the dominance of Abstract Expressionism when he was an art student in the mid- to late 1950s. These early lessons are evident in his occasional passages of color and brushwork that are only loosely tied to representation and in his concern for solidly built compositions, whose play of elements across the two-dimensional canvas is as carefully considered as the illusions of figures and space that they create.

During the 1960s and 1970s, however, Goodman's steady commitment to representing the figure was hailed as an important alternative to abstract painting. The depth of his grounding

in the history of art, from Egyptian and classical sculpture to old master painting, is often richly apparent just beneath the surface of Goodman's familiar subjects, and makes his work equally of this moment and profoundly informed by the past. This foundation has given his work a gravity and sense of purpose that are both a virtue and a liability in an age that so highly values novelty and in which so many artists relate their works to historical sources only by parody.

Goodman's work played a significant role in the renewed interest in the human figure as a subject for art during the 1960s and in the reappearance of realism that followed closely on its heels. He received national recognition early in his career, beginning in 1961 with Brian O'Doherty's review in *The New York Times* of his first one-person show in New York.[1] O'Doherty described Goodman's imagery as "a modern apocalypse, influenced by Freud and Gray's *Anatomy*." Subsequent critics also noted Goodman's preoccupation with expressive distortions of the human form, and connected him to the work of such diverse postwar European and American figurative artists as Francis Bacon and Leonard Baskin. One of Goodman's early self-portraits, a pastel drawing from 1958 or 1959 (plate 1), gives an indication of this approach. Goodman casts himself as a moon-faced, prematurely aged figure with oversize ears. It is a work of unconstrained fantasy, with leering heads jutting out behind his own to mock him. In a pen-and-ink drawing from about the same time (plate 2), however, which he made while in the Army, Goodman has used contour and some scratchy modeling to create a close likeness of his twenty-three-year-old face, dominated by thick, dark hair, eyebrows, and a moustache. By the intensity of his gaze, he appears to be studying himself closely in a mirror. These two approaches—of imaginative excess and close observation—

are at the core of Goodman's *oeuvre,* and, at the outset of his career, they existed relatively unintegrated.

Around 1963, Goodman's work became tighter and cooler—more "classical," as he has called it. In an effort to strengthen the credibility of his imagery, he moved away from the hot colors, irrational space, bizarre figures, and scenes of violence, decrepitude, or perversity that had characterized much of his work of the late 1950s and early 1960s. Instead, Goodman turned to closer observation of the human form and the urban landscape, often using photographs as sources. He structured pictorial space with an evident geometry and modeled three-dimensional forms with greater solidity, owing in part to his admiration for the example of Italian Renaissance masters, in particular Piero della Francesca and Masaccio.

This development in Goodman's work toward a more convincing illusion of reality coincided precisely with the renewed viability of naturalistic painting in the United States during the 1960s, as successive waves of "new realism," "new representationalism," and "superrealism" introduced artists such as Malcolm Morley, Chuck Close, Richard Estes, and Audrey Flack.[2] Based on recording the appearance of external reality—either directly or through photographs—these approaches shared a rejection of the existential tone of postwar figurative art in favor of a more deadpan manner that seemed to value the details of vision and form over humanist content. Goodman was often hailed as one of the young stars of this realist movement because of his own turn to a restrained, sharply focused style, despite his attachment to subjects that still suggested the themes of isolation, anxiety, and fear.

Over the next two decades, Goodman's commitment to painting and drawing the human form and his lifelong connection

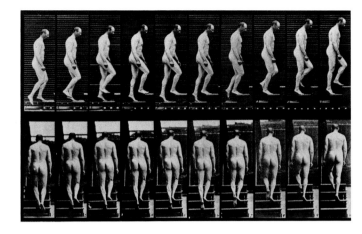

to Philadelphia, where he was born and raised and continues to live and work, strengthened the perception of his art as exemplary of a renewal of figurative realism. There is a distinct and vigorous tradition in Philadelphia of painting based on the careful recording of the observed world and taking the human figure as its primary subject. This reaches back at least as far as Charles Willson Peale and his family in the eighteenth century. A century later, Thomas Eakins's refinement of this empirical approach, bolstered by his meticulous constructions of the environments that his figures inhabit, would leave an indelible stamp on approaches to painting in the city. In the 1870s and 1880s, Eakins first taught and then served as director at the Pennsylvania Academy of the Fine Arts (where Goodman has taught since 1979), the oldest art school in the United States and one of the few that never abandoned a regime in which students work for the first year from plaster casts and thereafter from live models.

In addition to detailed study of the human figure by the traditional means of life drawing and anatomy, Eakins also relied extensively on photography to bolster the precision of his representations of the human form. This practice led him to encourage the English photographer Eadweard Muybridge to come to

Philadelphia in 1884 to conduct photographic studies of humans and animals in motion. Muybridge had his models walk, run, and perform other routines before banks of cameras whose shutters were triggered electronically to produce a sequential series of photographs (fig. 1).[3] In addition to making scientific contributions to such varied fields as medicine, anatomy, and engineering, Muybridge and Eakins hoped these photographic studies would provide a resource to help artists achieve a more precise verism in the representation of bodies in space and in motion.

Muybridge's photographic studies were a fundamental inspiration for Goodman—as they were for a number of other artists in the late 1950s and early 1960s—as he sought to refine his own visual language.[4] They had been republished as two widely available books, *The Human Figure in Motion* in 1955, which Goodman purchased around that time, and *Animals in Motion* in 1957. He had also seen some of the photographs on exhibition at the Philadelphia College of Art. In 1963, after he had turned to photography as a source for his art, Goodman began to make explicit use of Muybridge's work. While the studies provided useful information as Goodman improved the accuracy and solidity of his figures, this was not the primary interest they held for him.

Instead, Goodman was fascinated with the narrative possibilities of the sequential system and with the emotional tone of Muybridge's photographic settings in which gridded backgrounds and large numbers measured the space to allow for more precise evaluation of the models' movements.

*Man Being Shot* (fig. 2) and *Eclipse* (plate 3) both show Goodman integrating Muybridge's idea of the sequential development of a single action with grids and numbers, which create environments of cold mensuration for unfolding human dramas. In *Eclipse,* a man at the left climbs atop a step ladder to hang himself. At the right, his limp body is surrounded by a group of figures, impassive and puzzlingly undressed. The lines and numbers underscore the scene as a before-and-after sequence: one central vertical line extends to the floor to establish a clear division between the two halves, the numbers repeat on each side of the line, and the circle on the wall appears first in front and then behind the man's body to mark the distance it swung as he jumped off the ladder.

Goodman's infusion of Muybridge's idiom with charged content, distancing it from the original empirical intent, indicates that achieving the convincing illusion of reality was already far from his primary goal; as he noted later, in 1968: "I sometimes paint a realistic picture in order to justify logically something unreal."[5] Goodman's many self-portraits provide striking examples of the way in which he often begins with familiar, visible phenomena, then pushes his observations to the point at which they evoke something beyond the visual world. A large charcoal and conté crayon self-portrait from 1988, *Head with Red* (plate 37), powerfully unites the strains of mimesis and fantasy that were seen as separate tendencies in Goodman's two early self-portraits (plates 1 and 2). Here Goodman sets a colossal likeness of his own head, severed at the neck, atop a block. His tight mouth, flared

nostril, and cool gaze convey an attitude difficult to decipher, but seeming to range between scornful stoicism and mute pleading. This expression is intensified by the swath of red that stains his upper head. Not traceable to any actual cause or phenomenon, the impact of this abstract field of color becomes even more intense, perhaps connoting shame, jealousy, or rage.

This drawing gives the sense of offering the viewer a deeply revealing look into the artist's psyche. One could hardly imagine another motivation for displaying himself as subject to this mixture of abasement and aggrandizement. Moreover, we are thoroughly conditioned by the history of the genre of self-portraiture to expect self-revelation. As a whole, Goodman's body of self-portraits encourages this expectation, often reinforcing the stereotype of the artist as long-suffering and gripped by neuroses. We have good reason to believe the artist is trying to tell us something about himself when we look from the small sepia *Man Yelling* (fig. 3), to the unsparing *Self-Portrait* of 1983–84 (fig. 4), to the skull-like monuments of *Self-Portrait— Red* (plate 27) and *Self-Portrait—Black* (plate 28), to the *Self-Portrait with Arm Raised* (plate 49), whose gesture suggests preparation for throat slitting as much as shaving. But in Goodman's case, the sense of extreme self-revelation is better seen as theatrics. Rather than accurately reflecting an inner reality, his self-portraits— and, one could argue, all self-portraits—are constructions of identity that take place in and for the public eye. Goodman's presentation of himself in these dramatic, multifaceted roles insinuates that identity itself is a fluid and artificial entity.

Goodman's many portraits, which are primarily of his family members, also begin with a basis in likeness, but, in most cases, upset the expectations that we harbor of attaining some brush with intimacy, or even a glimpse of unique individuality, in the

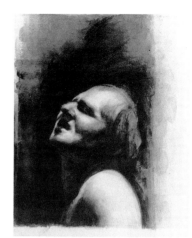

Figure 3
Sidney Goodman
*Man Yelling,* 1981–84
Sepia wash on paper
18½ x 15¼ inches (47 x 38.7 cm)
*Private collection*

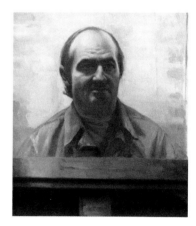

Figure 4
Sidney Goodman
*Self-Portrait,* 1983–84
Oil on canvas
28 x 24 inches (71.1 x 61 cm)
*Private collection, courtesy The More Gallery, Inc., Philadelphia*

image. Portraiture is a genre founded on the understanding of the face as the most vital field for expressing the uniqueness of an individual.[6] In two portraits of his wife, *Pam in a Dark Mood* (plate 17) and *Smiling Girl* (plate 18), Goodman uses the standard means of light and shadow to establish the volume of the head and define its particular features, but then exaggerates these value contrasts to achieve destabilizing results. Bright highlights next to deep shadows compartmentalize and fragment the two faces. The dark hollows of the eyes appear as empty sockets, especially next to the bleached cheeks. The shadows that her chin casts on her upper chest have such a strong presence in their depth of overlapping umbra and penumbra that they compromise the primacy of the face as the area of greatest density and complexity, instead drawing attention to her neck and shoulders. In each case, the individuality and vitality of the face are sacrificed as it becomes mask-like; when these two drawings are seen together, they evoke the timeless personae of Comedy and Tragedy.

As he does with most of his portraits, Goodman based these two images on photographs made with his thirty-year-old black-and-white Polaroid camera.[7] He values the images this camera produces in part for the way they give him just enough information but not too much, leaving ample room to stretch, distort, and infuse, so that the initial connection to reality is, in the end, just a point of departure. In addition to Goodman's own manipulations of the photographic source, the snapshot's ability to capture a slice of reality and freeze it for repeated examination creates an inherent distance from reality. It is already a fragment, an elliptical abstraction of tone on a small paper surface. Moreover, fixing an image at a single point in time only underscores the march of time away from that point; the result

is an emotional impact beyond what is conveyed by the nominal subject as the photograph inevitably comes to suggest mortality as an underlying theme. These two works convey something of this sense of the *vanitas* of the snapshot: *Pam in a Dark Mood,* with its death-mask face, and *Smiling Girl,* which seems to address us across an unbridgeable distance of overcharged nostalgia.

Goodman's primary interest, then, whether he uses photographs or direct observation of the world as a starting point, lies in exceeding rather than confirming the "facts" of vision. Realism in art, in contrast—as an approach rather than a specific historical movement—is generally understood as a commitment to recording the perceptual data gathered from the world of observable phenomena. Of course, no modern account of realism is so naïve as to assume the possibility of perfectly replicating the visible world—as ancient accounts praised the Greek painter Zeuxis for depicting grapes so convincingly that birds flew down to eat them. We are, nonetheless, still attached to the notion that a faithful transcription of the visual information yielded by sight puts us in closer proximity to the truth. Realism seeks to hide its own process of making meaning in the hope of achieving greater authority or "truthfulness."

Goodman, however, is at pains to insist on the image's constructed and provisional nature. Even when he takes the everyday world as his subject, it is put through a process in which its features are distorted, suppressed, or intensified in the service of expressing something beneath or behind the observable surface— that is, something that is best implied in the slippage between the recognizable and what is unexplained or mysterious.

It is tempting to insist on Goodman's distance from the practice of realism by calling him an "anti-realist," or by reclaiming and redefining the term "superrealist," which is so narrowly

identified with a slick, photographic presentation, but could be used to indicate a superseding of realism. But in the end, the most accurate perspective, and one that is richer in consequence, is to consider Goodman as a figurative artist working in an allegorical manner. Allegory as a visual mode functions in just the opposite manner of realism.[8] Some of its strategies include disrupting narrative flow, piling up disjointed fragments, incorporating references to prior images and texts, isolating figures to emphasize their role as personifications of concepts, and using images with multiple associations to draw attention to the presence of many layers of meaning and the necessity of interpretation. All these means serve to frustrate a straightforward reception of the image, which would consume the work for the story told or for the information conveyed. Instead, an allegorical image must be grappled with: its meanings are wrought by a process of hypotheses being advanced, checked against the visual signs, refined, and advanced again until a satisfying, although not necessarily definitive, resolution is attained.

As an American figurative artist working in an allegorical manner, Goodman does have his predecessors. In the 1920s and 1930s, Regionalist and Social Realist painters often used allegory to make explicit comments on their surroundings, either as praise of rural and small-town life or as criticism of social ills and oppression. Many figurative artists in the 1940s and 1950s created allegorical work that has been uneasily assimilated into one or another subcategory of realism, such as magic realism or romantic realism. Ranging from the tightly painted scenes of Paul Cadmus, George Tooker, Jared French, or Peter Blume to the more expressionist works of Philip Evergood, Edwin Dickinson, and Rico Lebrun, or the late work of Joseph Hirsch and Jack Levine, these artists frequently began with the familiar

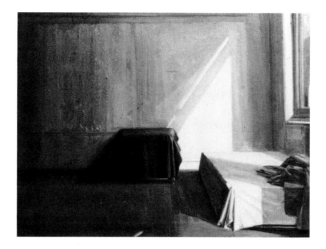

Figure 5
Sidney Goodman
*Third Floor Studio*, 1972–73
Oil on canvas
18 x 25 inches (45.7 x 63.5 cm)
*Collection Dr. and Mrs. Leo Chalfen*

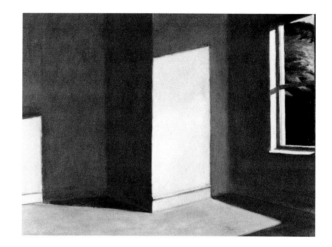

Figure 6
Edward Hopper
(American, 1882–1967)
*Sun in an Empty Room*, 1963
Oil on canvas
28¾ x 39½ inches (73 x 100.3 cm)
*Private collection*

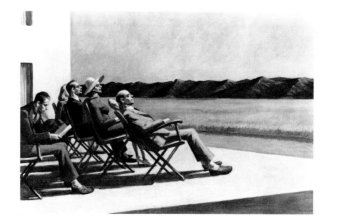

Figure 7
Edward Hopper
(American, 1882–1967)
*People in the Sun*, 1960
Oil on canvas
40⅜ x 60⅜ inches (102.6 x 153.4 cm)
*National Museum of American Art, Washington, D.C. /Art Resource, New York*

Figure 8
Sidney Goodman
*Crowd at Tisbury Fair*, 1976
Graphite on paper
11¼ x 19½ inches (28.6 x 49.5 cm)
*Photograph courtesy Terry Dintenfass, Inc.,
in association with Salander-O'Reilly Galleries,
New York*

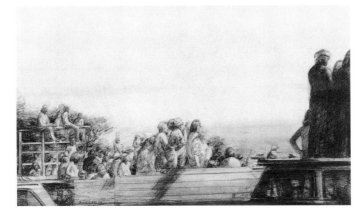

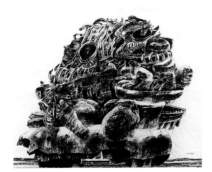

Figure 9
Sidney Goodman
*Once upon an Era*, 1960
Ink on rice paper
24¾ x 34¼ inches (62.9 x 87 cm)
*Whitney Museum of American Art, New York.
Purchase, with funds from the Neysa McMein
Purchase Award, 61.45*

world. But they then altered its appearance by various means to make comments about the human condition that were more ambiguous but no less affecting than those of the Regionalists and Social Realists.

The late work of Edward Hopper also provides an important antecedent, particularly for Goodman's more austere work of the 1970s, although Goodman has always rejected the notion of a direct influence. Goodman shares Hopper's interest in creating enigmatic scenes using strong contrasts of sunlight and shadow, overtly geometric compositions, and isolated human figures observed in mundane activities. Goodman's study of an empty room, *Third Floor Studio* (fig. 5), recalls Hopper's *Sun in an Empty Room* (fig. 6) in its angular shaft of light and sense of vacancy. And Goodman's *Crowd Scene* (plate 13) at first seems uncannily reminiscent of Hopper's *People in the Sun* (fig. 7) in developing an unsettling sense of mystery by focusing the gazes of its subjects outside the scope of our own vision. (Figure 8 shows the origin of *Crowd Scene* in a sketch he made at a summer fair on Martha's Vineyard.) But Hopper's figures, in the end, are soaking in the rays, not staring at an unknown spectacle, and the work does not aspire to the sense of grandeur and portentousness that Goodman's painting achieves.[9]

Over the last fifteen years, Goodman's work has sometimes left the world of the probable, even as a starting place, far behind to create images whose status as allegories is more overt. By presenting a collision of unexpected elements whose implications defy any cohesive narrative, *A Waste* (plate 29) epitomizes the way a painting structured as an allegory challenges the viewer to form an interpretation. *A Waste* is dominated by a mountainous trash heap where twisted car and body parts commingle. A photographer trains his camera on a man hanging upside down, his arms sprawled, his head dripping blood. The man's legs dissolve into the pile, thereby violating the most basic distinction between animate form and inanimate matter (plate 30 is a study of this central figure). To the left hangs another upside-down body, this one headless and eviscerated. A figure at the right, dressed in overalls, gloves, and cap, appears to be a trashman, his face masked, one imagines, against the stench. Three figures at the left explore or scavenge. The piling up of human and automobile or industrial parts into a twisted mass is a motif spanning Goodman's career from the early drawing *Once upon an Era* (fig. 9) to the recent work *Demolition Site* (plate 54), where the wreckage, while not actually containing body parts, still suggests the human anatomy. Goodman's experiences, as victim and witness, with serious car accidents as a child and young adult no doubt provided a certain impetus for these images. But by generalizing and recontextualizing them, he allows for a more comprehensive impact, well beyond the memory of specific events.

*A Waste* signals not only the destruction of human lives that we witness in the image, but waste as the aftermath of total devastation. This is humanity laid to waste, barely distinguishable from a pile of refuse. The upside-down position of the two central figures graphically evokes this state of disorder and terror

by their violent upending. Goodman's intention to give his image a deep resonance is underscored by the way these two figures recall precedents of religious imagery. They owe a strong debt to celebrated depictions of Saint Peter, who was crucified upside down (fig. 10). Another art historical precedent is a memorable painting in the Philadelphia Museum of Art (a collection Goodman knows intimately), Rubens's *Prometheus Bound* (fig. 11), in which Prometheus's tortured body is strapped, head down, to a rock, his stomach torn open by the eagle that devours his liver. While Goodman's painting is not intentionally a contemporary version of this classical myth, its parallels with Rubens's image and the myth are striking, except that now Prometheus appears as an unheroic Everyman, preyed upon by the photographer who transforms tragedy into spectacle.

Unlike *A Waste,* whose fantastic scenario and colliding of fragmented elements are recognizably allegorical, Goodman's works from the late 1960s and 1970s seem to present convincingly realistic images of observed scenes. In these lucid images of models in the studio, his parents in their store, or sunbathing women, the beautifully rendered play of light on varied textures and the convincing placement of bodies and objects in space imply that mimesis is their overriding concern and achievement. But even in these works, it is allegory, with its plurality of allusions and distance from the readily observable surface of the world, that structures the images.

In *Figures in a Landscape* (plate 8), a man and a woman sit on either side of a child who straddles a large red Hippity-Hop ball. We recognize the artist here and correctly assume that this is his own family, although clearly not a happy one. Each figure exists in his or her own world, remote from us and each other. The emotions that the three impassive figures so resolutely conceal

are nonetheless visible, as if displaced onto the surrounding environment. The slant of late daylight and the short, stop-and-go brushstrokes that organize the entire image give the landscape an unsettled, almost distressed quality. The dark sky and clouds that collide over the bowed head of the child create a brooding tone that further escalates the emotional intensity.[10]

At the same time, this is an image almost serene in its classical sense of structure. The woman, child, and two balls line up firmly on axis, and the horizon line, buttressed by the buildings, presents a nearly uninterrupted sweep above the figures' heads. This is no casual, slice-of-life image; the pictorial elements are as carefully aligned in their own constellation as the stars and planets. The ordinariness of this scene, and its tension between imposed order and dynamic expression, create the dramatic clash between restraint and impending eruption that draws us in to speculate on a charged picture of family relationships.

Even the title *Figures in a Landscape,* innocuous as it seems, intensifies the sense that interpretation is required to close the gap between strong feeling and incomplete narrative. The term "figure" is a most abstract designation for the human form. It accords to the three people here not much more humanity than the distinction of being separate from a ground against which they appear. The remainder of the title, "in a landscape," is also less than the informative description we might hope for— as tight-lipped as the figures themselves. Goodman's titles are generally such terse understatements as this. Affixed to highly evocative imagery as they usually are, they often come across as reverse hyperbole. Their very withholding of information urges us to project meaning into the work, as the incongruity between evidence and denial draws us to speculate. These are images that beg explanation.

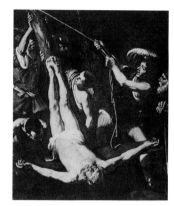

Figure 10
Copy of a lost painting by
Michelangelo Merisi, called Caravaggio
(Italian, 1573–1610)
*Crucifixion of Saint Peter,* 1600s
91⅜ x 79⅛ inches (232 x 201 cm)
*The State Hermitage Museum, Saint Petersburg*

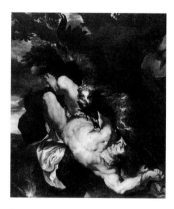

Figure 11
Peter Paul Rubens
(Flemish, 1577–1640)
and Frans Snyders
(Flemish, 1579–1657)
*Prometheus Bound*
Begun c. 1611–12, completed by 1618
Oil on canvas
95½ x 82½ inches (242.6 x 209.5 cm)
*Philadelphia Museum of Art. Purchased with the*
*W. P. Wilstach Fund. W1950-3-1*

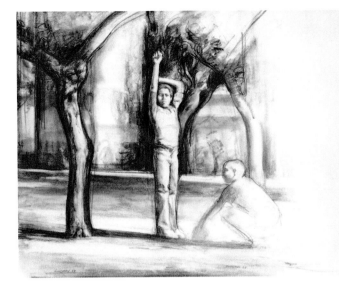

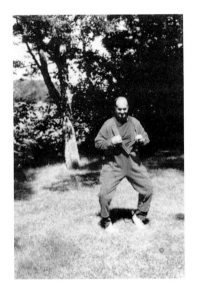

*Boy with Raised Arm* (plate 38) extends the sense of isolation of *Figures in a Landscape* to somewhat different effect. Here, an African American youth raises his arm in a familiar sign of power, resistance, and racial pride.[11] The source for this work came in the form of Goodman's photographs of boys playing in Philadelphia's Rittenhouse Square. In a study for this painting, one of the other youths remained, crouching and seeming to hold a ball (fig. 12). The removal of this second figure from the final work enhances the remaining boy's symbolic role; he appears as a solitary presence in a somewhat amorphous context, emblematic of the external forces that have begun to press on him at the crossroads of childhood and adulthood. His forceful gesture and mature face belie his still youthful body and innocent demeanor, evident even in the way he supports his upraised arm like a schoolchild waiting to answer a question. He is a classic protagonist whose heroic resistance to fate is all the more tragic for its futility. The flame-like glow of late afternoon sun in the background underscores this sense of inevitability, as does his athletic jacket tossed casually on the ground that, when looked

at closely, takes on an animate presence: with limbs sticking out to the side of a white torso and the red-ringed collar opening onto a cavity with too much volume for an empty coat, it evokes the limp body of a slaughtered lamb, a poignant symbol for the boy's life.

An isolated, life-size figure with a similarly enigmatic presence is the subject of *On the Ball* (plate 31). "On the ball," of course, is a colloquial expression for attentiveness or alertness. But this is not a simple visualization of that familiar phrase, for the image resonates with a number of meanings. We recognize the figure as the artist, wearing a jumpsuit and clown-like sneakers, and perched improbably atop a sooty pink globe (see fig. 13 for a photograph Goodman used as a source). His arms are drawn up close to his body, defensively, like a boxer's. One hand clutches his lapel as if for reassurance, the other is almost delicately extended as if for balance. His knees are bent to stabilize his position on the ball, and their bowleggedness contributes to an appearance of foolishness, as do the bagginess and wrinkled contour of his jumpsuit.[12] The setting is nebulous, with the ball emerging out of darkness and broad, smudgy strokes connecting various parts of the image. A shadow behind the figure's upper body that falls on no particular surface intensifies his presence and creates some sense of depth. His dark grimace, shadowy eyes, and slight forward cant impart an attitude of menace. Dominating the globe, he reads like a contemporary Nemesis, the classical goddess of divine retribution (fig. 14), demonstrating fatal control over the world. But, in light of his absurd gestures and pose, he also suggests an archetypal clown condemned to maintain this precarious balancing act forever.

A curious reversal on these images of solitary figures subjected to the pressure of external forces is effected in another

very large drawing, *Easter Sunday* (plate 36). Here, in a fusion of scenes that Goodman observed in Rittenhouse Square on an Easter morning, a little girl plays intently with her toy bunnies as a huge rabbit looms over her. Absorbed in her imaginary activity, she shows no awareness of his presence. Is he, in fact, an independent creature or solely a projection of her imagination? This seems to be a classic scenario, where the inhabitants of one's psyche—one's demons—take on a life of their own. The many representations in art and literature, including those by Hieronymous Bosch and Gustave Flaubert, of the Temptation of Saint Anthony, whose physical desires materialized as goblins and accosted him as he fasted in the desert, provide notable examples.

In other works, rather than the isolated figure dominated by external or internal forces, it is precisely the opposite phenomenon—the coming together of individuals into a cohesive ensemble—that inspires Goodman's image. The idea of the ensemble is most fully developed in one of his latest works, *Vitas* (plate 55), which presents a gathering at the beach. It is an upbeat image with many points of tender and joyous physical contact between the figures. The individual people have an heroic presence: they are pushed close to the front of the picture in a compressed space, and we look up at their large and solidly modeled forms as if we were lying in the sand among them. The features of their faces are strongly rendered so that each is a distinct type. Together they offer a sense of ethnic diversity, although Goodman combines and reshuffles the vocabulary of facial characteristics to create an appearance of variety without ethnographic specificity. The work presents a cross-section of people, where all differences among individuals are made part of a comprehensive representation of a common humanity. The title, *Vitas,* appropriately, comes from the Latin word for "life."[13]

For the last decade, Goodman has created his figures mostly out of his imagination. From so many years of observing and recording people in everyday life with an artist's eye, he has amassed a vast mental repertoire of facial features, gestures, and body types. As the artist describes: "When I say [an image is] made up, it's not only made up, it's almost like it's observed from my memory.... I'll see somebody's face…[and] it's almost inadvertently I'm looking at the structure of a forehead or I'm looking at the way the light is hitting them, so it's almost like I'm mentally recording something that I'm looking at, visually, with no camera." This source in his mind's eye in part explains the fluidity and flexibility with which Goodman selects and constructs each figure's appearance. It also illuminates his use of generalized types: with types he can evoke a strongly characterized presence rather than the specificity of individual identity that would restrain his imagination's tendency toward heightened expression.

Goodman also continues to use photographs as visual aids in creating his images. Scattered around his studio are numerous clippings from magazines, newspapers, and clothing catalogues that serve as points of reference for how an arm might bend, or how light might strike a cheekbone at a particular angle, or how a certain color might be used. He also frequently assigns himself, family members, or professional models specific poses or gestures that he records with his Polaroid. Other materials that function as tools in his creative process include picture books on art, war, and foreign cultures, his children's toys, small Pleistocene models that he sculpts, and postcards of old master paintings—all of which litter the studio (figs. 15 and 16). From high culture and low, from the past and the present, these varied source materials are raw matter for his imagination in a manner

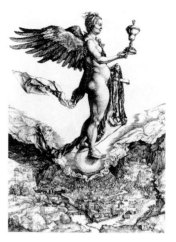

Figure 14
Albrecht Dürer
(German, 1471–1528)
*Nemesis*, 1501–3
Engraving
33⅜ x 22⅞ inches (84.6 x 58.2 cm)
*Kupferstichkabinett, Staatliche Museen zu Berlin PK*

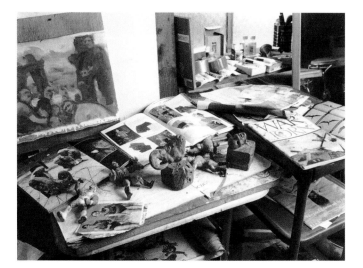

of working that Goodman compares to free association or musical improvisation, but that also parallels the structure of allegory whereby a synthesis of diverse elements with abundant associations makes the final image a complex, multilayered affair.

Sometimes the connection to a found image remains fairly direct in the final work. *Bloody Head with Fist* (plate 52), for example, is based on a newspaper headshot (the precise source now forgotten) of a performance artist (see fig. 16, upper left), although the original photograph included neither the hand pulling at his hair nor the blood on his face seen in Goodman's drawing. Goodman's imagination seems to have been stimulated by the exposed neck, the tautness of the bent head, and the sharp vertical division of the collar, all of which suggested to him the possibility of the more violent scenario that he constructed in the drawing. For Goodman, the most generic black-and-white images seem to make the best sources of inspiration. Their original function was to deliver information to as wide an audience as possible, and so they are not overrefined with an artist's vision; such images leave plenty of room for Goodman's own imaginative reworkings.[14] Two sketches of murderers made

in 1968 provide an earlier example of this working method. Their sullen stares equate perfectly with their source in newspaper mug shots, while the tight cropping and overlayed grids, traceable to Goodman's interest in Muybridge, evoke an aura of punishment (figs. 17 and 18).[15]

*Day Break* (plate 41) also has photographic origins but is less tied to a specific image than *Bloody Head with Fist*. Instead, numerous images from international photojournalism provided Goodman with a general inspiration for this painting of clamoring and gesturing men atop a boulder that vaguely recalls some felled colossus. As he made sketches to work out the composition, Goodman continued to refer to photographic sources, including his snapshots of men raising their arms in a variety of gestures as they rode in a car in a Puerto Rican parade in Philadelphia (see fig. 16, lower right). The inspiration provided by news photography and snapshots is also evident in the way the figures are pressed up close to the front of the image and randomly cropped along the bottom. Less readily apparent is the cultural background of the figures, who are characterized by dark complexions, broad features, and an unexpected variety of

dress that unites men in suits with others in athletic outfits. The exact nature of the event is similarly obscure. The men's expressions and gestures are celebratory, but whether they are rejoicing over a soccer win or unleashing their euphoria after a political victory is left to the viewer to decide.

A range of familiar imagery also inspires *Waste Management, Inc.* (plate 40), but in this case with a more pointed mingling of sources from high and low culture. Goodman has said that among the visual sources for the two imposing figures framing the center of his painting was Hans Holbein's *Ambassadors* (fig. 19), one of the first full-length, life-size portraits of the Northern Renaissance, and one that presents a profound interlacing of pride in worldly accomplishment with the awareness of mortality, symbolized by the distorted projection of the skull across the foreground. Despite this art historical allusion to an image of *vanitas*, or the contemplation of death, *Waste Management, Inc.,* is more recognizable as a scene of two hulking trashmen atop a pile of debris preparing to toss garbage into a truck. Their brutish faces call to mind the misshapen features of aging boxers—a subject in which Goodman has expressed particular interest—and give them a pathetic quality. They are not the heroes implied by their massive physiques, but what Goodman calls "pugs."[16]

The pose of the two figures, holding between them a cloth heavy with trash, also recalls another Renaissance precedent, one that the artist says was not consciously intended but whose visual similarities are too strong for us to ignore. In Renaissance depictions of Christ's Entombment, such as a painting by Raphael (fig. 20), the body of Christ is usually shown cradled in a winding cloth and placed centrally, framed by the figures who support his weight. In *Waste Management, Inc.,* the trash truck, squared off like a mausoleum, even suggests the open tomb that awaits

Christ's body. The stationary poses of Goodman's men, who, unlike Raphael's, seem not to strain against the weight they carry, may be due to the deliberate reference to Holbein's motionless ambassadors. These allusions to two great themes of European art, the *vanitas* and the Entombment, lend a gravity to Goodman's image that explains in part why it seems so removed from a scene of ordinary trash collecting. The low perspective, framing the men and truck against an expanse of dramatic sky, contributes to our sense that something of unexpected importance is happening. Yet, the raw, nearly caricatured presence of the trashmen grounds this image in the everyday world, prompting an awareness of our society's great distance from its spiritual traditions.

Goodman's approach to the acts of seeing and representing creates a complex synthesis. He interweaves observation, fantasy, memory, and preexisting imagery in a process that he has described as "conjuring." In some works, Goodman makes vision itself the primary subject, thereby overtly signaling his awareness of his creative process as an integral part of the structure and content of his work. *Girl Twice* (plate 6) presents a double portrait of a young girl up to her ankles in tub water. Although she appears somewhat older, her knock-kneed stance, skinny limbs, and potbelly belong to a four- or five-year-old. The two images could disclose alternate sides of the girl's personality: on the left, she is wide-eyed but still inward turned; on the right, her tipped-back head and open mouth convey greater self-assuredness.

But the double image also refers directly to the physical qualities of the act of looking. Since at least the mid-nineteenth century, scientists and artists alike have been fascinated by the fact that our two eyes see the world from slightly different vantage points and thus register and synthesize different

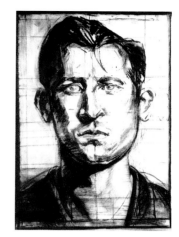

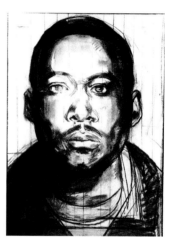

Figure 17
Sidney Goodman
*James Earl Ray,* 1968
Charcoal on paper
21½ x 17½ inches (54.6 x 44.4 cm)
*Collection of the artist*

Figure 18
Sidney Goodman
*Bobby Rogers,* 1968
Charcoal on paper
21⅝ x 17½ inches (55 x 44.5 cm)
*Library of Congress, Washington, D.C. Ben and Beatrice Goldstein Foundation Collection, Prints and Photographs Division*

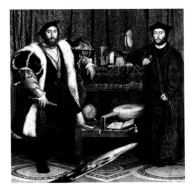

Figure 19
Hans Holbein the Younger
(German, 1497/98–1543)
*Jean de Dinteville and Georges de Selve*
*(The Ambassadors)*, 1533
Oil on panel
81½ x 82½ inches (207 x 209.5 cm)
*Courtesy The Trustees, The National Gallery, London*

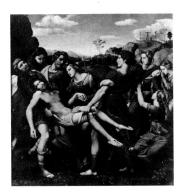

Figure 20
Raphael (Italian, 1483–1520)
*The Entombment*, 1507
Oil on panel
184 x 176 inches (467.4 x 447 cm)
*Galleria Borghese, Rome*

information, the physiological phenomenon known as binocularity. Paul Cézanne, for example, used broken contours around objects and a shifting passage between planes as a way to indicate his struggle to fix the fluctuating results of binocular vision on the immobile surface of the canvas. In contrast, in *Girl Twice* Goodman anchors the subject in place by a crisp contour, tight brushwork, and the distinction between her warm skin tones and the icy setting, together enhancing her firm, almost iconic presence. He then registers the eyes' binocularity by doubling the image. This is a literal act that has its own double and contradictory implications, for it makes an emphatic statement about Goodman's creative process—which is based on looking and relooking—while at the same time negating the certainty of visual facts. The sense of objectivity created by the overall clarity of this painting—with its precisely detailed observation of complex shadow variations on different surfaces and materials such as water, porcelain, and flesh—is, in the end, pushed beyond objectivity by the simple act of repetition: rather than providing more information, seeing an image twice with slight variations undermines its credibility, as neither side alone possesses the authority of uniqueness.

In *Blind Singers* (plate 39), Goodman makes an equally complex synthesis of the physical and metaphoric possibilities of vision. Here three African American street singers stand on a Philadelphia sidewalk. Blurry shadows in which an arm or body takes shape close in from the edges of the painting, giving the impression that we look at the singers from the midst of a crowd. This blurriness literalizes our status as viewers of the painting by equating our role as observers *of* the image with observers *in* the image. The dark shapes that press in on our peripheral vision while we try to see the performance make palpable the

physicality of seeing. But this visual obstruction also alludes to the three men's own impaired sight, re-creating the circumscription they must experience, where vision is at best a sliver of light between confused darknesses. The blackened windows behind the men reinforce our understanding of their sightlessness. Moreover, this literal constriction of vision serves as a metaphor for the struggle against oppression in general, where the words "vision" and "clarity" have often served as inspirational concepts. Diminutive in size and set against the backdrop of an overscaled building, these three men nonetheless convey heroism. Unable even to see the oppressive forces that encroach upon them, they stand fast and sing as an act of resistance and perseverance.

Goodman's use of allegory is at its most expansive in his most ambitious series of paintings to date—the enormous triptych consisting of *Free Fall* (plate 46), *Transition* (plate 47), and *Sightseers* (plate 48). Each painting measures nearly nine feet high by eighteen feet long. Even individually, they make an imposing public statement, addressing the viewer on a monumental scale. Unlike traditional allegorical paintings, however, Goodman's triptych has no predetermined religious, political, or ethical function nor a single definitive interpretation. His images contain the possibility for multiple meanings, but, in a peculiar twist on the allegorical convention, they deliberately withhold any resolution as to a conclusive reading.

The left-hand panel, *Free Fall,* shows a chaotic mass of figures tumbling down a slope (see fig. 21).[17] It is a jumble of heads, bodies, and limbs in a compressed space. Oddly, the figures do not all obey the same laws of gravity; most fall down to the left, but some fall upward or back into the hillside. Moreover, conditioned as we are to read from the left, we expect that the bodies

would fall to the right, with the draining away of color echoing their downward slide to make an overwhelming statement of devolution. But Goodman is not so methodical, and instead was interested in the ambiguity and tension that resulted from the sense of two forces—the emerging color and the falling bodies—moving against each other rather than in tandem.[18]

The central painting, *Transition,* begins where *Free Fall* left off, with a dark, nearly monochromatic left side. Its title makes numerous references, including to its pivotal position in the triptych. Across its surface there is a development from the most undifferentiated state of raw matter, where humans merge with the ground, toward more complex form. The infusion of color underscores this evolution. The figures who have fully emerged from the earth and rock represent a range of types, from the standing man with rolled sleeves to the china-doll-like girl with dark hollows for eyes. But these individuals are still mostly massed in two boulder-like clusters, as if they had attained only some intermediary stage in the genesis of full individuality between the cascading frenzy of bodies in *Free Fall* and the statuesque presence of the climbers in *Sightseers. Transition* also suggests a more urgent state of flux, as the distant sky to which the figures point might herald not the veritable dawning of a new day but imminent nuclear disaster, a notion, however, that is intentionally left inconclusive.

In the right-hand painting of the triptych, *Sightseers,* four life-size figures in yellow rain gear stand on a snowy mountain slope gazing into the distance. Beyond them rises a Matterhorn-like peak, magnificent in its impossibly sheer sides and its radiance. A group of mountain goats provide a foil to the humans, who by all rights should appear as heroes, given their ascendancy to this position atop a sublime alpine setting. Yet any claim to heroicism by the climbers is undermined by a biting humor: their proportions are a little squat, their physiques a little portly, and their outfits suggest they have just descended from a lift, as the title also indicates. Their status as intruders is underscored by the slightly quizzical look of the displaced goats.

The far figure's outstretched arm, placed exactly at the intersection with the mountain slope so that it is isolated against the sky, is a repeated gesture linking all three panels of the triptych. Rather than the desperation that the upraised arms express in *Free Fall,* or the ambivalence between hope and terror suggested in *Transition,* in *Sightseers* the gesture's implications are more ironic. The figure extends his arm and huge hand toward the awe-inspiring vista as if he were a conquering leader or explorer, but the sovereignty of his gesture comes off as shallow imperialism. Luxury tourists in matching slickers, these poseurs are harbingers of despoliation: the surveyor's stakes are already planted beside them in the hillside.

The overall themes of *Free Fall, Transition,* and *Sightseers* seem to be the age-old concerns of Western culture: chaos versus order; survival, exploration, and conquest; and fear and aspiration. The three-part sequence even seems to parallel the Christian tripartite division of the eternal afterlife into states of damnation, purgatory, and salvation. But absent in this contemporary allegory is any authoritative text—written or oral—that would conclusively link the images to these or other such concepts and tie them together into a grand symbolic scheme of cultural signification. Instead, at the center of Goodman's images is a clearing where meaning awaits assignment and resolution is kept at bay. His works have a significance more compelling for their openness, for into this clearing rushes the viewer with his or her own free associations, overproducing to fill in the blanks and

Figure 21
Sidney Goodman
Polaroid for *Free Fall* (plate 46), one of four taken at Skowhegan School of Painting and Sculpture in Maine, 1985
*Collection of the artist*

create coherence. The range of possible interpretation for the images is left deliberately broad, as boundless, in fact, as the viewer's imagination. It is this dynamic that is a key to the power in these paintings and much of Goodman's work. They attain a tremendous presence and efficacy not only because they present images of powerful subjects, nor just because they present them forcefully, as indeed they do—on a large scale, with vigorous brushwork, and in an ever richer palette. They also achieve their grip on our psyche in large part through Goodman's ability to engage his viewer's emotions, memory, and intellect to participate actively in the process of making meaning out of his images.

For Goodman, the open-ended, expansive nature of his allegories seems to be the most viable form for connecting with a contemporary audience characterized foremost by heterogeneity. We are no longer so firmly guided by the relative homogeneity of a dominant culture that in the past provided authoritative and unifying texts or visual languages for interpreting works of art. This has been expanded and fragmented by the increasingly diversified makeup of contemporary society, combined with a general cultural emphasis on individuality that has developed since Romanticism. Goodman, however, does not use an allegorical language to emphasize our distance from this past; for him the use of allegory signifies neither elegy nor anachronism. Instead, by opening up the center of his works to a plurality of coexisting signification that accommodates and, in fact, requires the viewer's active engagement, he has found a way to make allegorical figurative art a continuingly vital means of communication.

Goodman is certainly not alone among figurative artists in presenting allegories that contain multiple interpretive possibilities and that require active viewer participation. Over the course of the last century, ambivalence and ambiguity have been embraced by American artists from Albert Pinkham Ryder to Edward Hopper to Eric Fischl, David Salle, and Mark Tansey. During the 1950s, especially in the generation preceding Goodman, the use of an unspecific symbolism replaced the more pointed allegories of the 1930s and 1940s. Personal and psychological issues, colored by an existential outlook that saw the human condition as defined by alienation and anxiety, took precedence over social concerns. This trend culminated in the *New Images of Man* exhibition in 1959 at the Museum of Modern Art in New York, an international survey of contemporary figurative art that included Willem de Kooning, Jackson Pollock, Richard Diebenkorn, Leonard Baskin, Rico Lebrun, Leon Golub, Karel Appel, Francis Bacon, and Alberto Giacometti. The exhibition catalogue hailed its contents as humanist cries of anguish and expressions of rebellion appropriate to an age deeply scarred by Buchenwald and Hiroshima.[19] In fact, the show's title became synonymous with representations of the human form as besieged and assaulted. Goodman's use of ambiguity, however, while originally deriving from this milieu, steers clear of any sweeping statement about the human condition in favor of a more open-ended complexity.

While the human figure has served as the primary vehicle of allegorical painting, Goodman's landscapes too can be understood as allegories. Both as settings for human dramas and as primary subjects in themselves, they are often invested with a potency that far exceeds more familiar representations of natural phenomena. It is this excess that provides a key to the significance of his landscapes by connecting Goodman's work to the philosophical concept of the sublime. Since the eighteenth century, the discourse of the sublime has found in nature's ability to produce phenomena of astonishing, sometimes terrifying

power—storms, waterfalls, isolated mountain passes, volcanic eruptions—answers to some of the questions that religion had long been counted on to provide. This discourse in turn served as the basis of a new language for expressing profound human experience. This language bloomed fully over the next century in Romanticism and has recurred periodically throughout the twentieth century. Wassily Kandinsky's preoccupation with themes of the Deluge and Apocalypse is one manifestation, as is the desire voiced by Abstract Expressionist painters such as Barnett Newman and Mark Rothko to create experiences of boundless, all-engulfing space and color without the usual moorings of figure-ground relationships.

Edmund Burke, the eighteenth-century British philosopher of the sublime, described it as "that state of the soul in which all its motions are suspended, with some degree of horror." He elaborated on this experience, saying, "In this case the mind is so entirely filled with its object, that it cannot entertain any other, nor by consequence reason on that object which employs it."[20] In being defined as that which lies beyond our mind's ability to grasp, the sublime resembles the way we have seen allegory function in Goodman's work. The excesses of the sublime reveal the inability of imagery and language to contain certain subjects by representing them. This creates a gap, the "suspension of all motions" that, like allegory, shows these images or texts to be relative, human constructs attempting, in the case of the sublime, to distill the essence of certain intense feelings and embed them externally, in nature, in the hope of gaining insight into life's mysteries.

In keeping with the experience of the sublime, Goodman presses his images up close to the surface so that they fill our eyes and mind; there is usually very little available visual space

for us to enter, let alone any illusion of great depth in which to escape. In his work, nature is often presented as immense and untamed, forewarning impending disaster. Goodman's allusion to the sublime is perhaps most evident in his five-part series of paintings called *The Elements,* where the images of *Fire, Air, Earth, Water* (plates 19–22), and *The Archangel* (fig. 22) already have a rich metaphoric history. The theme of the four essential natural elements dates from antiquity. In classical and medieval philosophy they were considered to be the basic constituents of the physical universe, while a pure fifth element—"quintessence"—was believed to be the medium of heavenly bodies.

For Goodman *The Elements* series grew out of the idea of painting a single image of a natural element. As he described: "I was just going to do a painting of fire, and then one led to another. The fire painting I started to think about almost the way Monet would paint the water lilies, just the phenomenon of it, the look of it, and then I started to think about the other elements, and then the whole idea started to grow." Goodman's description of an organic process of creation is a good reminder of his intuitive working method and the way in which his ideas are generally founded in the visual, not the literary: rather than starting with an *a priori* concept, message, or text, he developed the theme of *The Elements* out of a search for images that resonate with sublime feeling.

Goodman's interest in fire as a subject had already surfaced in 1967 in a drawing of a trash incinerator in Maple Shade, New Jersey (fig. 23), followed by a painting of the same image (*Maple Shade Disposal Area,* 1968; Terry Dintenfass, Inc., New York), and, seven years later, a close-up of that incinerator (plate 11). During the 1980s, Goodman began to use fire more freely as a metaphoric element, exaggerated or detached from

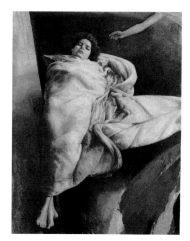

Figure 22
Sidney Goodman
*The Elements—Archangel,* 1982–83
Oil on canvas
108 x 84 inches (274.3 x 213.4 cm)
*Collection Mr. and Mrs. John J. Turchi, Jr.*

Figure 23
Sidney Goodman
*Maple Shade Incinerator, 1967*
Charcoal on paper
25¾ x 40 inches (65.4 x 101.6 cm)
*Collection Dr. and Mrs. Marvin Sinkoff*

Figure 24
Sidney Goodman
*Two Views,* c. 1991
Pastel on paper
6 x 12 inches (15.2 x 30.5 cm) each
(mounted together)
*Terry Dintenfass, Inc., in association with*
*Salander-O'Reilly Galleries, New York*

observed settings. Because of its dual capacity for empowerment and destruction, fire has traditionally been portrayed as having an ambivalent nature of purity and nurturing on the one hand and vengefulness on the other, or as possessing both female and male qualities. Goodman perfectly captures this dualism in a diptych from 1986–87. *Night Burn* (plate 32) shows a man hurtling through space, enshrouded by flames. Here fire is at once a sign of pleasure and of torture, as it suggests the state of being consumed by desire. In *Daydream* (plate 33), the fire of passion is domesticated, confined to the allusive pattern on the pillow of a woman who dreams of a new baby as her existing child slides off into the void. An earlier drawing, *Burning Vehicles* (plate 16), presents fire solely as a destructive agent, as overturned truck forms spew smoke and flame against a night sky. Small, shadowy figures in the foreground imply the vestige of a narrative event, but also underscore the intensity and violence of the fire by their own insubstantiality.

In *The Elements—Fire* (plate 19), all traces of human presence are removed. It is an all-consuming tower of flame that seems to bring the viewer into contact with a primal force. A vague structure indicates the former presence of a building, but not clearly enough to diminish the sense of a confrontation with pure

conflagration. Similarly, the towering butte in *The Elements—Earth* (plate 21) stands as an isolated emblem of power, with only a minimal sense of context given by the small segments of cliffs at either edge. Its thrust toward the heavens equates the earth with male virility. The gigantic presence of the wave in *The Elements—Water* (plate 22) is also expanded out of all proportion to what one might ever encounter in the physical world. Even its source in a photograph in a surfer magazine does not explain away its colossal scale and fury, which suggest an impending deluge more awesome than the experience of any natural phenomenon.

Goodman chose to represent *The Elements—Air* (plate 20) with the cumulus and towering nimbus clouds that presage storms. The drama of the clouds, combined with glimpses of distant blue sky, load this image of the most ethereal of the four natural elements with strong feeling: it seems to express an unbounded yearning or a desire for release into its atmospheric expanse. The fact that there is only a tiny platform of ground on which to imagine standing and no human presence actually shown makes this a glorious, measureless realm, while the division of the image into broad zones of floating color creates an almost abstract composition.

This effect is taken a step further in a later painting entitled *Landscape with Black Clouds* (plate 42), whose panoramic display of fire, smoke, and sky, pressed up close to the picture plane and playing out upon the narrow foreground stage of green ground, reads also as a dramatic composition of color fields. In a small pastel sketch for this work, Goodman contemplated including an ascending figure being observed by another on the ground (fig. 24). He also first called the finished work "Three Acts of Nature." In the end, he eliminated the human presence and made

the title less literal, deemphasizing the spiritual associations and allowing for a more expansive reading of the painting. Human presence in any of these images of natural phenomena would be redundant at best; on the one hand, they show nature as a potent metaphor for our most extreme emotions, and thus the human element is already embodied as a projection of feeling onto the environment. At the same time, these pictures suggest that nature is divine, so that humankind is appropriately banished. Its appearance would only trivialize the settings, as Goodman has deliberately done in *Sightseers* (see plate 48).

The old question arises, of course, of how Goodman can be said to make images of the sublime if the sublime is that which exceeds representation. But Goodman is not re-creating a sublime experience for us in his works, as if we were actually standing in the presence of the overwhelming natural event. The large size of many of his works is impressive, but this is a sign pointing to his interest in the realm of the overpowering rather than an attempt actually to belittle us or persuade us of something. Moreover, the concept of the sublime carries within it a commentary about its own susceptibility to representation: on the one hand, it presents images of overwhelming power; on the other, these images are inherently partial and inadequate since they are about what lies beyond description. As with Goodman's approach to allegory in general, his use of the sublime always contains an absence at its center, in this case an absence of the possibility of experiencing that which is shown. Instead, his images leave us with the desire for that experience, however overwhelming we fear it would be.

This dynamic that characterizes the sublime—between presence and absence, and fear and desire—is not confined to Goodman's landscapes. In fact, it is perhaps even more evident in his treatment of sexuality. Originally the sublime was defined in opposition to the beautiful. Since at least the eighteenth century, beauty has been understood as an ideal condition engendering a disinterested appreciation and producing a calm, uplifting pleasure, unlike the more stormy emotions elicited by the sublime. Desire, which would seem at first to be a response to the appearance of beauty, instead represents a disruption of this ideal. Its surge punctures the smooth veneer of contemplative perception. In Goodman's treatment of sexuality, eroticism is often presented so as to maximize the effects of this disturbance. On occasion, it erupts into a full-scale allegory of the sublime.

Goodman often locates his nudes in a shallow, amorphous space, a compositional device particularly well suited to the creation of erotic subjects. The body as an image is most available for visual consumption when it is presented as pure posture, that is, pushed up close to the pictorial surface, lacking a sense of complex interior life, and free from the impediments of an architectural structure or detailed environment out of which it would have to be visually ripped to be possessed.[21] The women in *Figures on a Dune* (plate 12) and *Waking Up* (plate 45) are just such types of figures. But in both cases, the appeal to desire conveyed by their postures of availability or vulnerability is derailed by other factors. In *Figures on a Dune* the central woman lies on the beach, limp beneath the hot sun. But more than simply enervated, she seems entirely unapproachable. An air of spiritual remove pervades the scene: she floats in an expanse of pearly sand as if it were nebula, attended by a similarly remote girl.

In *Waking Up*, we see a woman against a dark shadow entangled in a mass of sheets. She raises a hand to her head in a classic gesture of submission, revealing her soft underarm and chest. At the left, a figure seen from below seems to fly toward the

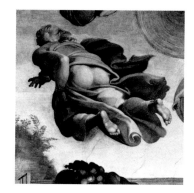

Figure 25
Michelangelo Buonarroti
(Italian, 1475–1564)
*The Creation of the Sun and the Moon* (detail), c. 1511–12
Fresco
*Sistine Chapel, Vatican City*

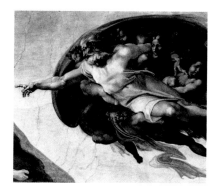

Figure 26
Michelangelo Buonarroti
(Italian, 1475–1564)
*The Creation of Adam* (detail)
c. 1511–12
Fresco
*Sistine Chapel, Vatican City*

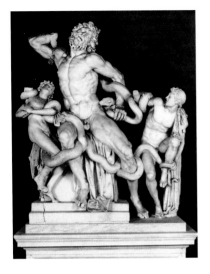

Figure 27
*Laocoon,* first century A.D.
Roman copy of the Greek original
Marble
Height 72⅜ inches (184 cm)
*Musei Vaticani, Vatican City*

heavens in a swirl of clothes, legs, and feet. Any imagined privileged access to the nude accorded the viewer, as if she existed purely for our visual satisfaction, is usurped by this fleeing figure who seems to depart after his own visitation. The acute perspective on the left side and the fabric masses that contain infant and umbilical forms recall two panels on the Sistine Chapel ceiling (figs. 25 and 26), supporting the idea that this, too, is an image of creation. But it is unclear whether the woman's awakening is a straining to consciousness after procreation or after her own coming into being.

In the large early painting of a nude in the studio from 1971–72, *Room 318* (plate 7), the tension between allure and withholding is particularly subtle. Set back at a distance into the room, the model sits at the edge of a table, unabashedly returning our gaze. Solidly and carefully rendered, she has a relaxed, sensual presence. Her breasts are exposed, but her crossed legs conceal her sex. Goodman has said of the various associations prompted by this image, "It could be a model—it could be just a woman in any kind of a room, or it could have been a room in a—I guess a whorehouse or something."²² In her resistance to playing out the roles we might assign to her—a resistance not confrontational but nonetheless unyielding—she seems reminiscent of Edouard Manet's *Olympia* (Musée d'Orsay, Paris), even accompanied by the same sly studio prop of the furry cat. But more than this, and unlike many of the figures in Goodman's later paintings, she is set into a convincingly three-dimensional space of cool light and geometrical structure that characterizes his work from this period. The single-point perspective, whose vanishing point is grounded in her own body, locks the nude into a precise architecture of spatial recession. This anchors her at a remove from the frontal plane of the canvas and from the

desiring gaze of the viewer, negating what might have at first seemed like a promising invitation.

A particularly unusual coupling of sexuality and restraint occurs in the graphite drawing *Laocoon and Nun* (plate 25), which Goodman made from his photographs of one of his students, a nun, posed in front of a plaster cast of the Hellenistic marble of the *Laocoon* (fig. 27). Laocoon was a Trojan priest who, along with his two sons, was strangled by sea snakes sent to punish him for desecrating the temple of Neptune by having had sex there with his wife. In addition to establishing a clash between pagan and Christian religion, posing a nun before this powerful male nude in Goodman's drawing sets up an obvious tension between the sacred and the profane. (Curiously, the placement of the nun under the boy's upraised hand mimics a benediction.) Moreover, the nun, in her vow of sexual abstinence, represents a striking counterpoint—or variation, if one envisages her vows as a marriage to God—to Laocoon's episode in the temple.²³

In other works, Goodman complicates the already loaded subject of eroticism even further by expanding the suggestions of aggression and victimization. *Urban Lovers* (plate 24) and *Love Knot* (plate 43) are two of his most directly erotic images, showing couples in the act of making love. In both works, the men's embraces look uncomfortably close to throttling and establish an ambiguity between sex and violence that is simultaneously ancient and entirely contemporary. In *Bright Sun* (plate 50) this ambiguity is made even more disturbing. A young boy lies in a shallow wading pool surrounded by colorful toys. He raises his arm to shield his eyes from the blazing sun, leaving his tender body and genitals exposed. His gesture seems driven by a desire for protection from more than the glare, as if not having to see something would make it go away or not happen. Whatever

looms over him casts a shadow that obscures the contour of his legs and seems to threaten a more complete eclipse. The tiny pool becomes an emotionally fraught realm where every detail takes on added weight: the fantastic sea creatures on the rim with their frenzied undertone, the boy's expressive shadow, and the pockets of shaded blue water that seem bottomless all subtly increase the central tension between innocent pleasure and unspeakable fear.

In *Nude on a Red Table* (plate 14) the intermingling of the themes of sex and violence comes to a head, quite literally, in one of Goodman's most profound and disturbing works. The naked female form lies heavily upon a small table, her legs and a hand hanging over the edges. She is convincingly modeled, although the value contrasts are so strong that they not only create mass and volume, but they also begin to carve the body into dissociated parts so that her potentially voluptuous form resembles a dense pile of limbs. Goodman has referred to this image as an exaggerated twist on the familiar idea of putting a woman on a pedestal,[24] thereby signaling his awareness of it as an extreme example of the sexism implicit in the tradition of depicting the female nude by making her an inert lump of flesh on display.

But the fact that this figure is missing her head takes this grim play on conventions to another level. Goodman began working with the motif of a large female figure crowded onto a small table in the mid-1960s. One of his earliest drawings of this subject, from 1966 (fig. 28), shows the origin of the image, as the model bunches herself up tightly so that we only see broad strands of charcoal hair spilling out from behind her knees. In a double image of this nude from the same year (fig. 29) and in a self-portrait from the following year (fig. 30), Goodman had already pushed the figure toward the appearance of headlessness,

Figure 28
Sidney Goodman
*Woman on Table,* 1966
Charcoal on paper
28 x 42¼ inches (71.1 x 107.3 cm)
*Estate of Albert M. Hackett*

Figure 29
Sidney Goodman
*Nudes on Table,* 1966
Charcoal on paper
32 x 41 inches (81.3 x 104.1 cm)
*Collection Mrs. Sue Erpf Van de Bovenkamp*

Figure 30
Sidney Goodman
*Self-Portrait in Studio,* 1967
Oil on canvas
67 x 79 inches (170.2 x 200.7 cm)
*Private collection*

concealing her head almost entirely behind a leg. Returning to this image ten years later in *Nude on a Red Table,* the head—whether imagined as not yet painted or as rubbed out—is clearly just absent rather than concealed. In its place, thick, wavy ribbons of red paint spill from the body. This highly disturbing image has occasionally prompted critics to accuse the artist of a misogynist intent.

This work is undeniably an assault, but not on women per se. As the viewer's eye moves across the image from left to right, it traces a path from realism to abstraction, from the illusion of the body in space to an awareness of the actual brushstrokes on the flat canvas. The open-ended or dissolving nature of the figure's head, along with the contour of the table, is a device that casts doubt on the entire image, exposing the trickery of the illusionism elsewhere in the painting. More significantly, Goodman uses incompletion and fragmentation to attack the very values upon which the whole edifice of the depiction of the female nude rests—unity, wholeness, and containment—which, in turn, provides the foundation for the classical definition of beauty.[25]

Curiously, the classical tradition has also provided a source for the fragmentation and obscurity that distinguish the sublime, as classical sculpture, whether found at temple sites or preserved in museums, in modern times has almost always been encountered in a broken and incomplete state. Its very fragmentation became part and parcel of its reception; not only embodying the values of classicism, the surviving statuary also signaled the rupture with this past and often became transformed into a source of eroticism, as if the violation of classicism's smooth and unbroken contours unleashed the passions. The fragmentary image, then, came to be a galvanizing link between the present and the past, and between desire and decay. Goodman's *Nude on a Red Table* pits the obscurity, fragmentation, and limitlessness that are the hallmarks of the sublime against the values of clarity and order that distinguish the still powerfully operative classical notion of beauty. This work is highly subversive in the way it initially embraces a tradition of restrained sensuality, only to confound it with stronger passions.

The fusion of sexuality and violence in this and other works by Goodman has strong connections to the twentieth-century concept of trauma, a psychological term used to describe a "medical" event or condition. In the experience of trauma, as in the experience of the sublime, a violent or overwhelming event fills the mind beyond its capacity to absorb and process. For this reason, trauma is often forgotten shortly after it occurs; it is occluded or repressed as a too-fragile consciousness seeks to protect itself. In this way, by being unavailable to accurate representation by the person who experienced the event, a trauma resists direct scrutiny. Instead, it makes its existence known indirectly, by disturbances of the surface of daily life such as irrational fears, hallucinations, unbidden preoccupations, or other obsessive or compulsive behavior. One historian has recently argued that the cycle of trauma—of occurrence, latency, and indirect manifestation—may be the most accurate model for understanding how history in general functions.[26] This model also has a striking resemblance to the way Goodman's works are overloaded beyond the immediately visible sources of explanation. Inscribed in his works are echoes of past events, images, or texts that, while not providing "solutions" to the pictures' meanings, do lend a powerful charge and suggest along what lines they are to be understood. One could imagine these disrupting agents as ghosts, a term felicitous for its double sense of a haunting presence and one who authors a text covertly—a ghost writer.

One significant "ghost" of trauma in Goodman's work is the Holocaust. At a half-century's remove, the Holocaust is still a battleground of remembering and forgetting, as it was from the beginning. It continues to make its presence felt by its disruptions of the surface of otherwise ordinary lives, as a subterranean wellspring of unnameable fear, distrust, and alienation. In some of Goodman's early works, such as *Survival* (fig. 31) and *Requiem* (fig. 32), the piling up of bodies directly recalls the famous photographs of concentration camp victims that he, together with a nation of disbelieving Americans, saw in *Life* magazine in 1945.[27] The artist's fascination with the human form, with its parts disjointed and jumbled together, clearly owes something to the early impression of these images, which hit that much more closely to home for a young Jew; as Goodman has stated, these photographs "had more impact because you realized with a slight change of location and I could have been there. My family—we could have been there."[28] With its isolated figure walking on an upper deck (inspired by the old Connie Mack baseball stadium in North Philadelphia) above limb-like debris scattered along the lower tier, *Stadium at Night* (plate 4) also seems to owe its conception to the perennial aftershock of terrors encountered in childhood. Similarly, the cedar chips in *Inside the Cage* (plate 26), which on closer inspection reveal themselves to be tiny human bodies, harken back to the *Life* photographs and other such images.

Goodman has described one of his latest paintings, *Spectacle* (plate 56), as a "contemporary holocaust image—not World War II, but what's happening now, what you see on TV." It takes the theme of sight and blindness that we encountered in *Girl Twice* (plate 6) and *Blind Singers* (plate 39), and construes it in terms of witnessing, a central issue in the experience of trauma

and in the art and literature that address the Holocaust.[29] The painting presents five variations in the tense interplay between seeing and not seeing. The cameraman looks directly at a pile of bodies but in a highly selective way, manipulating his vision to serve spectacle to a mass audience of consumers. The dehumanizing nature of his perspective is underscored by the mutation of his head into the camera itself. In the lower right a middle-aged couple wearing slight grimaces turn away. They are reminiscent of the young man who scurries out of the picture in *Waste Management, Inc.* (plate 40), but seem more deliberate in their attempt to put behind them that with which they cannot or will not come to terms. Two lovers copulate atop the bodies, as if blind to the gruesome foundation on which they act (although Goodman has mentioned that they could embody the cyclical nature of life, of renewal that springs from death). The piles of bodies are victims who saw the violence firsthand and, although they are eloquent in their utter silence, can no longer share the details of their stories. Finally, of course, there are the viewers—ourselves—in whose eyes these disparate allegories must be reconciled.

Despite the way that piles of bodies are engraved in our mind's eye as emblematic of the Holocaust, it is fire, in particular as manifested in "the image of the ovens spewing flames day and night," in the words of one scholar, that came to be a more potent and comprehensive "symbol of extermination, much more so than the gas chamber, where death occurs inside the walls, without external traces."[30] One of Goodman's recurrent industrial subjects, *Incinerator* (plate 11), ultimately gains its disruptive power from hints of just this association gathering behind its seemingly mundane facade. Across a large expanse of canvas, the interior and exterior of an incinerator fill the image, a rusty door

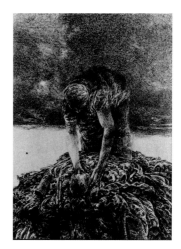

Figure 31
Sidney Goodman
*Survival*, 1962
Pen and ink on paper
*Photograph courtesy Terry Dintenfass, Inc., in association with Salander-O'Reilly Galleries, New York*

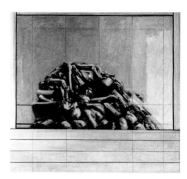

Figure 32
Sidney Goodman
*Requiem*, 1967
Oil on canvas
60 x 65 inches (152.4 x 165.1 cm)
*Terry Dintenfass, Inc., in association with Salander-O'Reilly Galleries, New York*

Figure 33
*The Crucified Christ with the Virgin,*
*Saint John the Evangelist, and Angels*
*with Instruments of the Passion* (detail)
c. 1460–90
Possibly southern Flanders
Painted oak
168 x 114 inches
(426.7 x 289.6 cm) (cross)
*Philadelphia Museum of Art. Purchased from the*
*George Grey Barnard Collection with Museum*
*funds. 1945-25-86*

separating the two. The cool, gleaming metal surface contrasts with the fiery inside. A shallow foreground is partially littered with debris. Only a glimpse of a distant semirural landscape provides any relief from the immediacy of the image. The masterful contrast between the inside and outside and the fascination of fire so well painted are surely enough to lend this image its force, as is the uncomfortable effect of close confrontation with an industrial apparatus usually kept at the margins of our lives, hidden in waste areas or behind fences. But the grip of this image is also more than this, as the pink armchair hints. The chair becomes the pivot point between us and the incinerator. Of course, its vacancy invites us into the picture to sit. But its emptiness also conveys an absence, unexplained but suggestive. And in its plump fleshiness the chair itself has a striking human presence, almost soliciting sympathy for its abandonment.[31]

However charged its impact when we detect it in works such as *Incinerator,* the Holocaust remains only one among many sources inhabiting Goodman's work, and even then it exists as an echo, not as an intentional program of representation. As current events in Chechnya, Bosnia, and Rwanda remind us and as Goodman's ever-growing collection of newspaper and magazine photographs would confirm, there are many other disastrous occurrences in modern history capable of providing images of human frailty and malevolence on a vast scale. Moreover, his images of the degradation of the human body—by fragmentation, by dissolution into inanimate matter, or by disposal with as little ceremony as trash—as seen in works such as *A Waste, Waste*

*Management, Inc.,* and *Free Fall,* have derived from sources far beyond the expected domains. A scan of some of the newspaper and magazine clippings on one of Goodman's work tables (see fig. 37) reveals images of sandbags stacked on an overloaded cart and a man standing atop a pile of tax forms to be mailed, both of which take on more sinister overtones as they crowd cheek by jowl with images of more horrific events.

In the collection of the Philadelphia Museum of Art, which Goodman knows so well, there is a fifteenth-century carving of a Crucifixion scene whose mound of skulls and bones from the hill of Golgotha offers an image of mortality and chaos as potent as any in contemporary history (fig. 33). Its resonance with some of Goodman's own works is not an example of any direct influence but a reminder of his connection to a tradition of art that addresses our most profound concerns in images of archetypal power, no matter the specific theology or the absence thereof. In Goodman's paintings and drawings, Christian imagery, Jewish identity, historical events, and a broad repertory of ancient and modern art all find a place. It is a virtue of his art, however, that it so strongly evokes these precedents while remaining entirely grounded in the objects and activities of our everyday world. In the end, Goodman's varied sources of inspirations serve as raw material that he fractures, shuffles, manipulates, and finally surpasses as the newly invented imagery that he brings forth manifests his own unique vision.

1. The exhibition was held at the Terry Dintenfass Gallery, where Goodman has continued to show to the present. See Brian O'Doherty, "Art: Sidney Goodman," *The New York Times,* December 23, 1961, sec. 1, p. 2.

2. The concept of a new realism was at first ill-defined, initially applied in various exhibitions and writing to minimalist sculpture, pop art, figurative painting, and eventually photorealism. For a summary of this history, see Frank H. Goodyear, Jr., *Contemporary American Realism Since 1960* (Boston, 1981), pp. 19–20.

3. Eadweard Muybridge, *Animal Locomotion* (Philadelphia, 1887).

4. A number of artists in the 1950s and early 1960s, including Francis Bacon, Sol LeWitt, Duane Michaels, Robert Smithson, and Mel Bochner, were interested in Muybridge's work for widely divergent reasons. For an exploration of Muybridge's influence on modern and contemporary photographers, see the catalogue of an exhibition at the Addison Gallery of American Art at the Phillips Academy by James L. Sheldon and Jock Reynolds, *Motion and Document, Sequence and Time: Eadweard Muybridge and Contemporary American Photography* (Andover, Mass., 1991).

5. Quoted in Vassar College Art Gallery, Poughkeepsie, New York, *Realism Now* (May 8–June 12, 1968), p. 28; essay by Linda Nochlin. This was one of the first exhibitions to present the ground swell of naturalistic work as a cohesive movement.

6. For a discussion of the history and implications of portraiture and self-portraiture, see Richard Brilliant, *Portraiture* (London, 1991).

7. When Goodman's first Polaroid camera finally broke in 1993, he was pleased to be able to replace it with another 30-year-old black-and-white Polaroid.

8. Allegory, as a literary mode, fell out of favor in the early 1800s. Romantic poets and theorists rejected it as nonaesthetic because of its tradition of serving ethical, religious, or political agendas. There was renewed interest in allegory by literary critics in the 1950s, at first because they saw their own acts of interpretation as an allegorical procedure—an uncovering of hidden meanings—but later they came to recognize allegory as an internal structure of the work itself. Over the next decade, literary historians expanded their understanding and definition of allegory; see in particular Angus Fletcher, *Allegory: The Theory of the Symbolic Mode* (Ithaca, 1964); Edwin Honig, *Dark Conceit: The Making of Allegory* (New York, 1966); and Maureen Quilligan, *The Language of Allegory: Defining the Genre* (Ithaca, 1979). (Quilligan points out that despite critical neglect, allegory was never totally abandoned by writers, as is evident in the twentieth century in work ranging from that of Franz Kafka to Thomas Pynchon.) There was another wave of renewed interest beginning in the 1980s, when allegory was seen by visual art critics as a distinctly postmodern mode. See, for example, Craig Owens's two-part article "The Allegorical Impulse: Toward a Theory of Postmodernism," *October,* vol. 12 (Spring 1980), pp. 67–86; vol. 13 (Summer 1980), pp. 59–80.

9. Discussing the scene in his 1990 interview with Marina Pacini for the Archives of American Art at the Smithsonian Institution in Washington, D.C., Goodman said that he "liked the scale of the figures and the way they were strung out. It was almost like a Greek frieze of figures, all moving in a horizontal direction, looking at something.... They could have been looking at anything. They could be looking at a drag race. They could be looking at a lynching, or a launching of a rocket" (p. 250 [for an edited version of the Pacini interview, see pp. 82–91 below]). Goodman recently mentioned that, in comparison to Hopper's *People in the Sun,* his *Crowd Scene* is "more ominous." He characterized Hopper's work as "Yankee realism"—as distinct from his own "ethnic, European roots"—saying that Hopper's work "has a different kind of poetry, a particularly American quality of loneliness, longing, and nostalgia" (conversation with the author, September 15, 1995. Unless otherwise noted, all quotes and statements attributed to the artist are from this conversation and others on February 24 and May 5, 1995.)

10. Goodman commented that "the way the blue plastic handle of the toy shovel is stuck into the sand, the sandbox almost becomes…like a little graveyard or something" (Pacini, Interview [unedited], Archives of American Art, p. 256).

11. This image was subsequently painted as a mural on a building at the corner of Powelton Avenue and Fortieth Street in Philadelphia by the Anti-Graffiti Network in 1991. Reaching a height of 44 feet, it is inscribed with a quote from Walt Whitman, chosen by Goodman: "I am large, I contain multitudes."

12. In classical sculpture, bowlegs were considered a sign of dimwittedness, and a tense posture with a complex contour was regarded as characteristic of groups whose human dignity had been assailed by life. See Richard Brilliant, *Gesture and Rank in Roman Art: The Use of Gestures to Denote Status in Roman Sculpture and Coinage,* Memoirs of the Connecticut Academy of Arts and Sciences, vol. 14 (New Haven, 1963), p. 12.

13. Actually, *vita* is the proper Latin term for "life." Goodman derived his title from the word "Vitas" printed on a handbag carried by a hospice worker who cared for his dying mother, which was the name of the hospice organization.

14. When I toured the exhibition *Sebastião Salgado: Workers* at the Philadelphia Museum of Art with Goodman in the spring of 1993, he was fascinated by the work and occasionally held up his fingers to make a viewing frame, focusing on smaller details within the images. He owns the exhibition catalogue, which lies around his studio, but it has provided no actual source material for his own art, as Salgado's vision is so distinct that he has already worked the kinds of transformations of his raw material that Goodman might do.

15. James Earl Ray assassinated Martin Luther King, Jr. Bobby Rogers killed a Philadelphia woman who was a student at the Philadelphia College of Art, where Goodman taught. Goodman says that he paired the lesser known Rogers with Ray in part out of a desire to present a black head with a white head, which reflects his interest in race and in types that is discussed below.

16. Goodman also termed them "pathetic brutes" because they are "doing the devil's work," a more sinister implication than is explored here but one that is in keeping with the discussion that follows of some of his other works.

17. At the lower right of the painting is fellow instructor Roy de Forest, reminiscent in his bearded droop of Michelangelo's self-portrait from the Sistine Chapel's *Last Judgment,* an appropriate allusion given the doomsday suggestion of the image.

18. Pacini, Interview (unedited), Archives of American Art, p. 123.

19. Peter Selz, *New Images of Man* (New York, 1959), p. 12. Goodman was not able to see this show, as he was serving in the Army, but he remembers the catalogue as influential.

20. Edmund Burke, *A Philosophical Enquiry into the Origin of Our Ideas of the Sublime and Beautiful,* ed. Adam Phillips (Oxford, 1990), p. 53.

21. For further discussion of the connection between posture and eroticism, see Norman Bryson, *Word and Image: French Painting of the Ancien Régime* (Cambridge, 1981), pp. 89–121.

22. Pacini, Interview (unedited), Archives of American Art, p. 257.

23. On the history of the *Laocoon,* see Margarete Bieber, *Laocoon: The Influence of the Group Since Its Rediscovery,* rev. and enl. ed. (Detroit, 1967). See also Simon Richter, *Laocoon's Body and the Aesthetics of Pain: Winckelmann, Lessing, Herder, Moritz, Goethe* (Detroit, 1992).

24. See p. 89 below.

25. For a discussion of the politics of the nude in relation to beauty and the sublime see Lynda Nead, *The Female Nude: Art, Obscenity, and Sexuality* (London, 1992).

26. Cathy Caruth, "Unclaimed Experience: Trauma and the Possibility of History," *Yale French Studies,* no. 79 (1991), pp. 181–92.

27. "The German Atrocities," *Life,* vol. 18, no. 19 (May 7, 1945), pp. 32–37.

28. See p. 88 below.

29. See, for example, Shoshana Felman, "In an Era of Testimony: Claude Lanzmann's *Shoah,*" *Yale French Studies,* no. 79 (1991), pp. 39–81.

30. Annette Wieviorka, "Jewish Identity in the First Accounts by Extermination Camp Survivors from France," *Yale French Studies,* no. 85 (1994), p. 138.

31. In a conversation on February 24, 1995, Goodman said that the pink armchair is "something I saw, based on observation. [It's] probably from somewhere else, like in a lot that's just strewn with them; they've got one just across the street [from my studio]. There's always one of these things around…usually gutted—it's like this horrible violation of some actual object, like somebody's guts are spilled out."

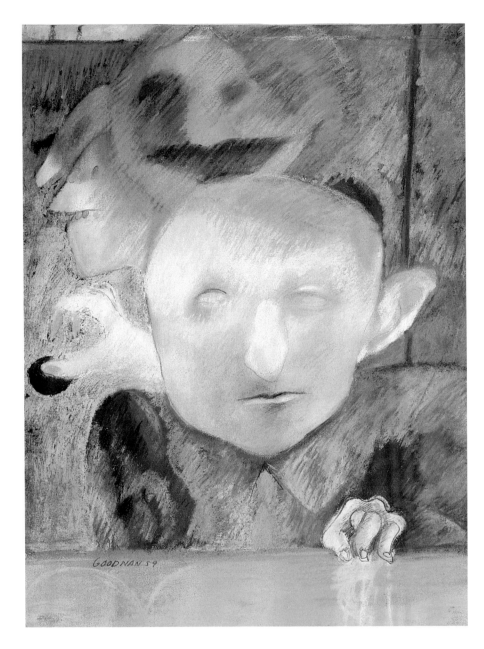

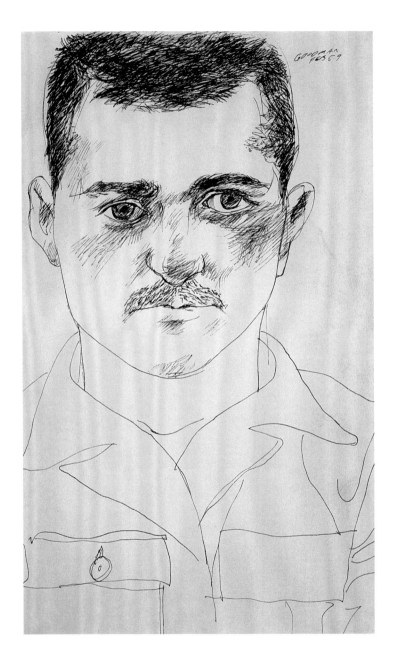

PLATE 1 *(above left)*
*Untitled (Self-Portrait)*
1958 or 1959 (dated 1959)
Pastel and graphite on paper
13⅞ x 10⅝ inches (35.2 x 27 cm)
*Collection Rodger LaPelle and Christine McGinnis*

PLATE 2 *(above right)*
*Self-Portrait—Fort Bliss*
1959
Pen and ink on paper
8⁷⁄₁₆ x 5⅛ inches (21.4 x 13 cm)
*Collection of the artist*

PLATE 3 *(opposite)*
*Eclipse*
1964
Oil on canvas
64¾ x 83½ inches (164.5 x 212.1 cm)
*The Syracuse University Art Collection*
NOT IN EXHIBITION

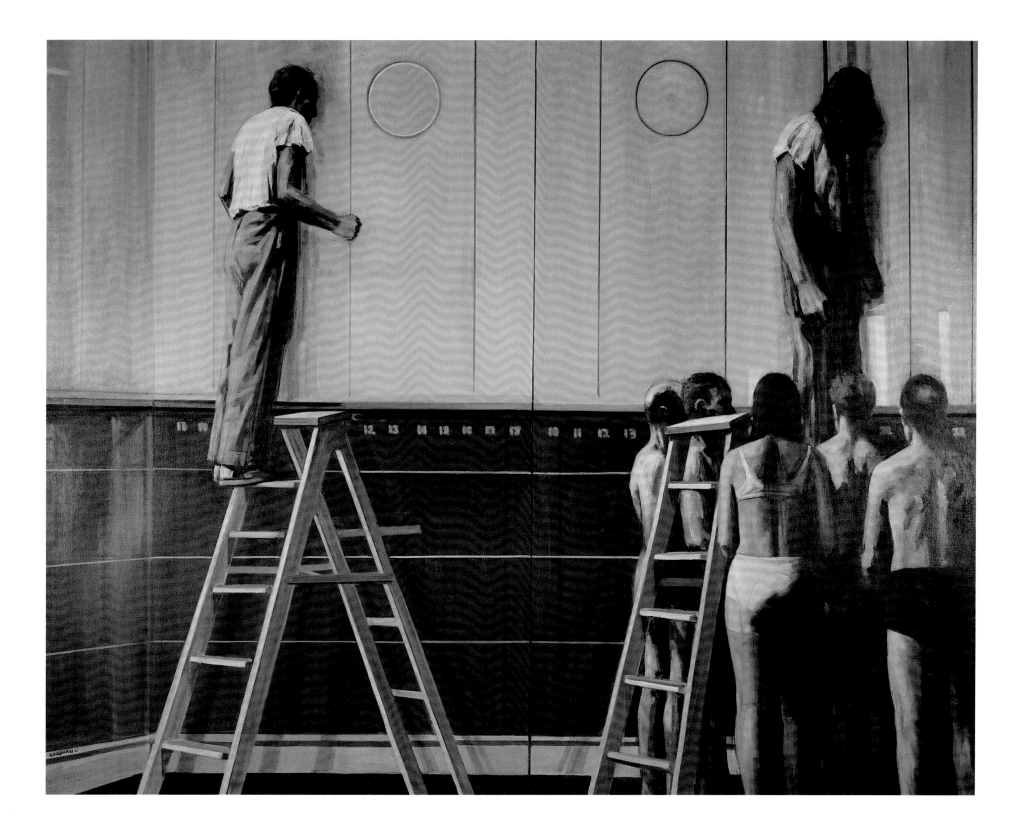

PLATE 4
*Stadium at Night*
1966
Charcoal on paper
32 x 22 inches (81.3 x 55.9 cm)
Collection Dr. Martin Cherkasky

PLATE 5
*Woman in Tub*
1967
Charcoal on paper
23½ x 25½ inches (59.7 x 64.8 cm)
Whitney Museum of American Art, New York.
Gift of Mr. and Mrs. James Stein

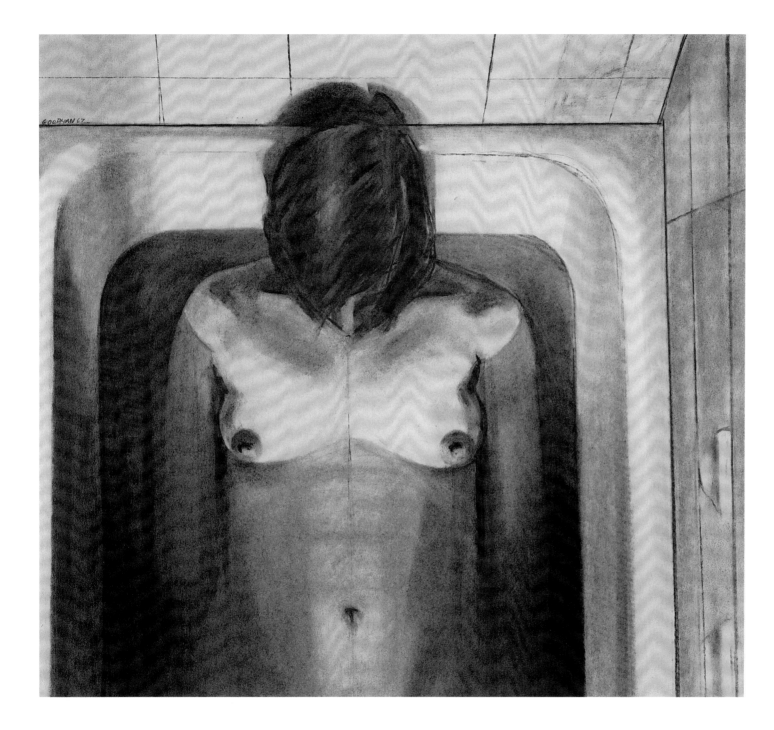

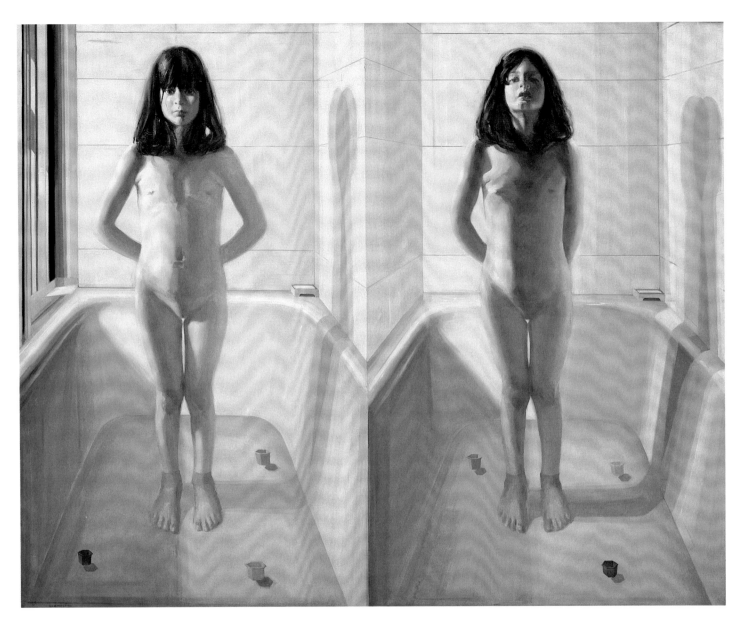

PLATE 6
*Girl Twice*
1969–70
Oil on canvas
63¾ x 79 inches (161.9 x 200.7 cm)
*Private collection*

PLATE 7
*Room 318*
1971–72
Oil on canvas
76 x 97 inches (193 x 246.4 cm)
*Whitney Museum of American Art, New York. Purchase with*
*funds from the National Endowment for the Arts, and the*
*Juliana Force Purchase Award, by exchange*

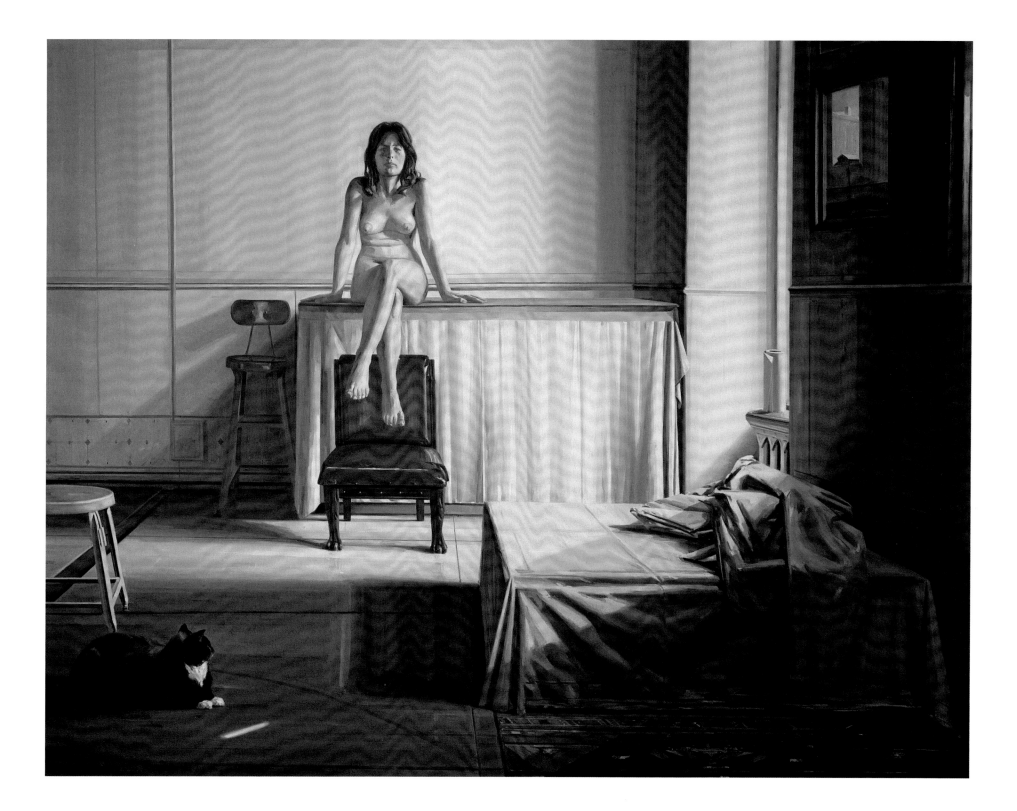

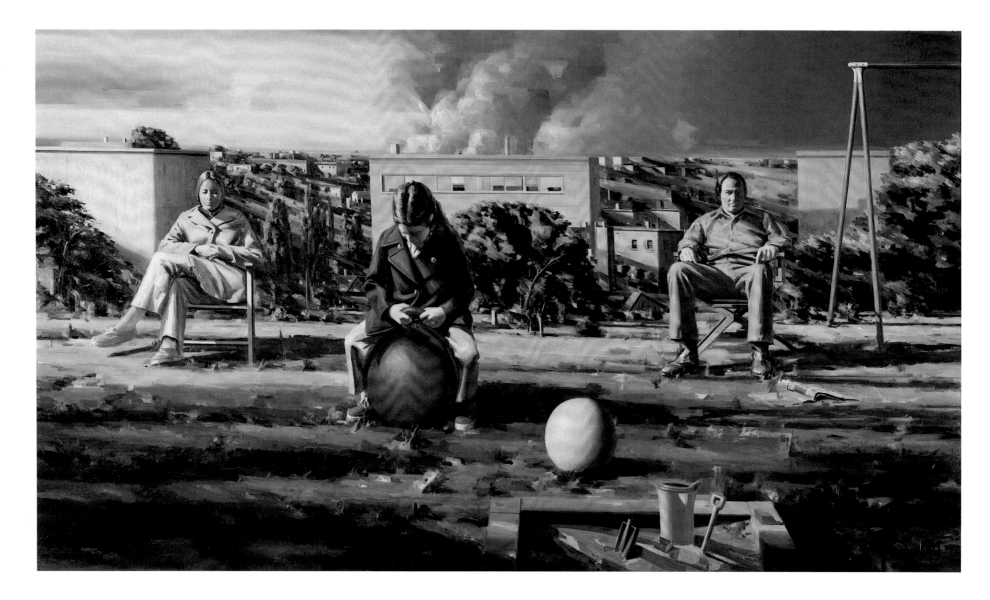

PLATE 8
*Figures in a Landscape*
1972–73
Oil on canvas
55 x 96 inches (139.7 x 243.8 cm)
*Philadelphia Museum of Art. Purchased with the Philadelphia*
*Foundation Fund (by exchange) and the Adele Haas Turner*
*and Beatrice Pastorius Turner Memorial Fund. 1974-112-1*

PLATE 9
*The Artist's Parents in the Store*
1973–75
Oil on canvas
58½ x 77 inches (148.6 x 195.6 cm)
*The Butler Institute of American Art, Youngstown, Ohio*

PLATE 10
*Project at Scranton*
1975
Oil on canvas
60 x 60 inches (152.4 x 152.4 cm)
*Private collection*

PLATE 11
*Incinerator*
1975
Oil on canvas
45⅝ x 97½ inches (115.9 x 247.6 cm)
*Rose Art Museum, Brandeis University, Waltham, Massachusetts.*
*Herbert W. Plimpton Collection*

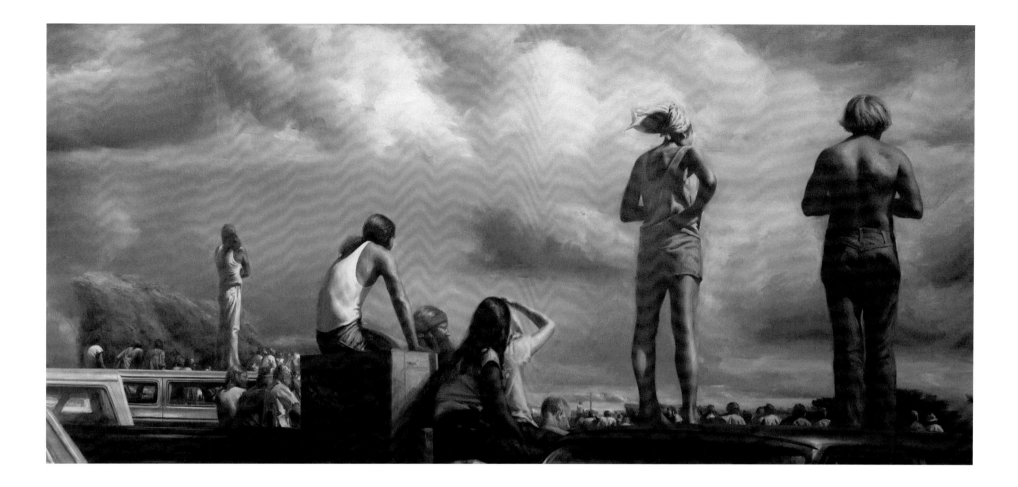

PLATE 12
*Figures on a Dune*
1977–78
Oil on canvas
58¼ x 80 inches (148 x 203.2 cm)
*Columbus Museum of Art, Columbus, Ohio.*
*Gift of Arthur J. and Sara Jo Kobacker*

PLATE 13
*Crowd Scene*
1977–79
Oil on canvas
65⅝ x 143⅝ inches (166.7 x 364.8 cm)
*Virginia Museum of Fine Arts, Richmond.*
*Gift of the Sydney and Frances Lewis Foundation*

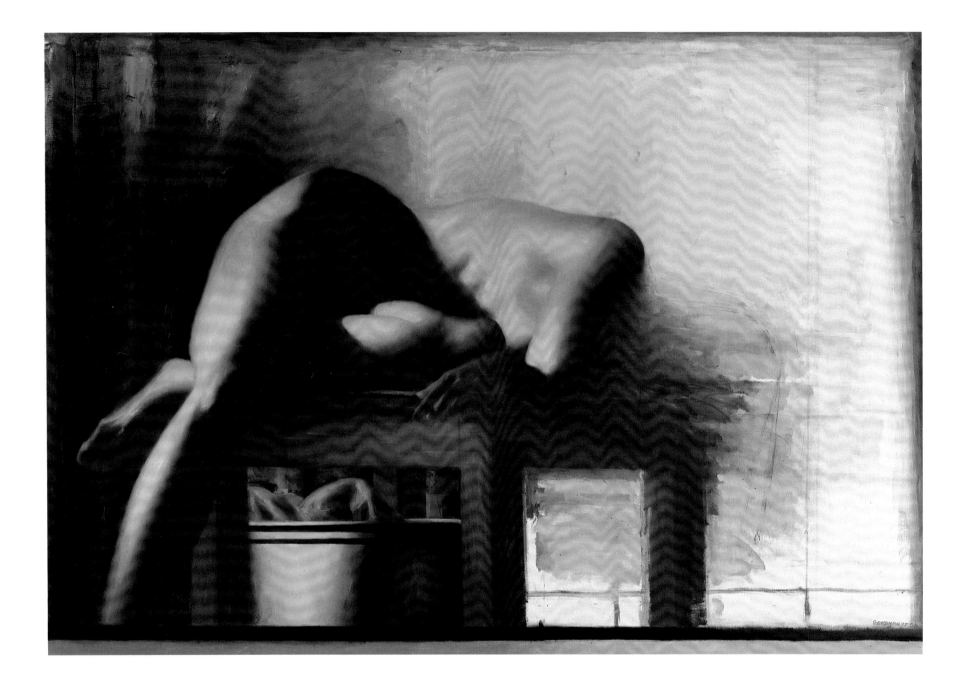

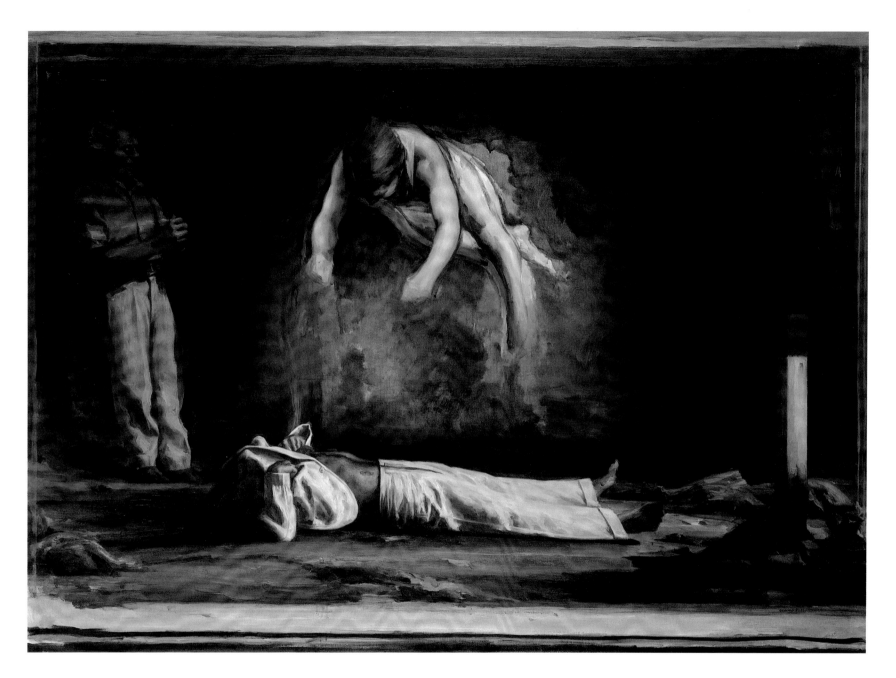

PLATE 14
*Nude on a Red Table*
1977–80
Oil on canvas
53½ x 77¾ inches (135.9 x 197.5 cm)
*Museum of American Art of the Pennsylvania Academy of the Fine Arts,*
*Philadelphia. Funds provided by the National Endowment for the Arts,*
*the Contemporary Arts Fund, and Mrs. H. Gates Lloyd*

PLATE 15
*The Quick and the Dead*
1980–81
Oil on canvas
66⅞ x 88⅝ inches (169.9 x 225.1 cm)
*The Metropolitan Museum of Art, New York. Purchase,*
*Riva and James J. Rochlis Gift, 1986*

47

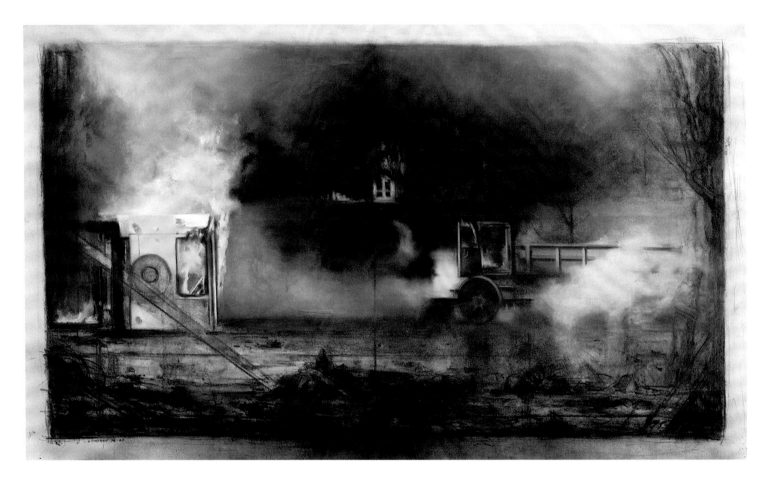

PLATE 16 *(above)*
*Burning Vehicles*
1978–80
Charcoal and pastel on paper
35 x 57 inches (88.9 x 144.8 cm)
*Collection Malcolm Holzman*

PLATE 17 *(opposite left)*
*Pam in a Dark Mood*
1982–83
Graphite on paper
34 x 23 inches (86.5 x 58.5 cm)
*The Art Institute of Chicago. Gift of Jalane and Richard Davidson*

PLATE 18 *(opposite right)*
*Smiling Girl*
1982–83
Graphite on paper
34½ x 21¼ inches (87.6 x 54 cm)
*Collection Jalane and Richard Davidson*

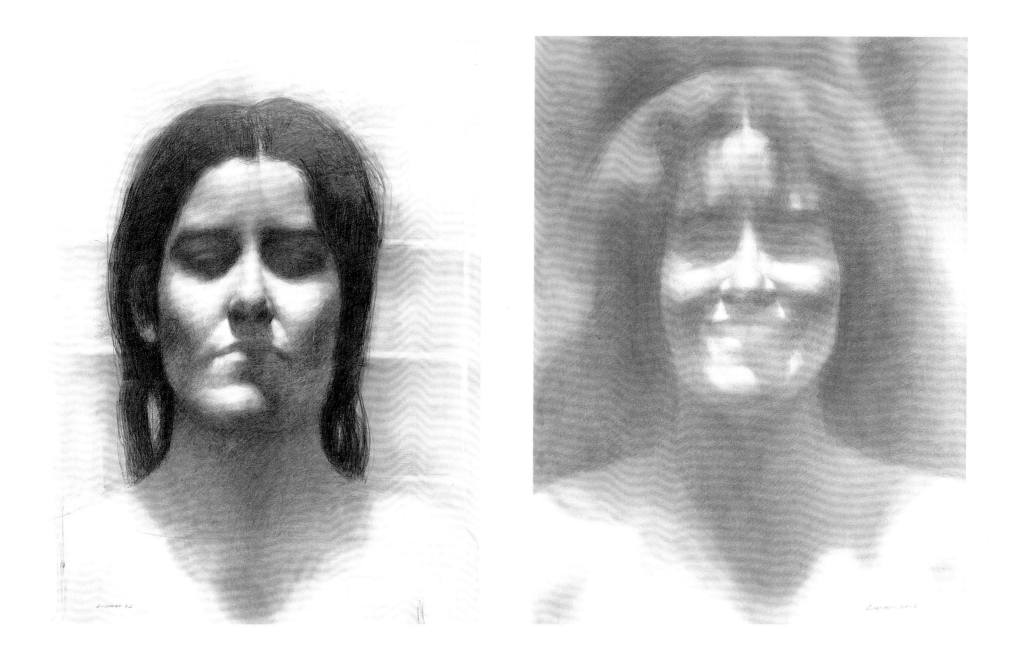

PLATE 19
*The Elements—Fire*
1979–82
Oil on canvas
96 x 76 inches (243.8 x 193 cm)
*Collection Mr. and Mrs. John J. Turchi, Jr.*

PLATE 20
*The Elements—Air*
1982–83
Oil on canvas
96 x 75 inches (243.8 x 190.5 cm)
*Collection Mr. and Mrs. John J. Turchi, Jr.*

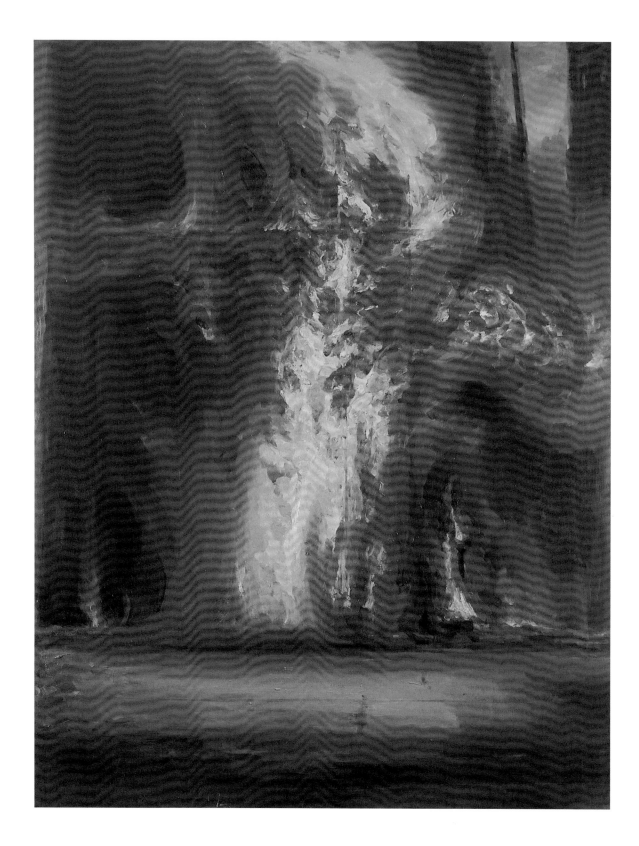

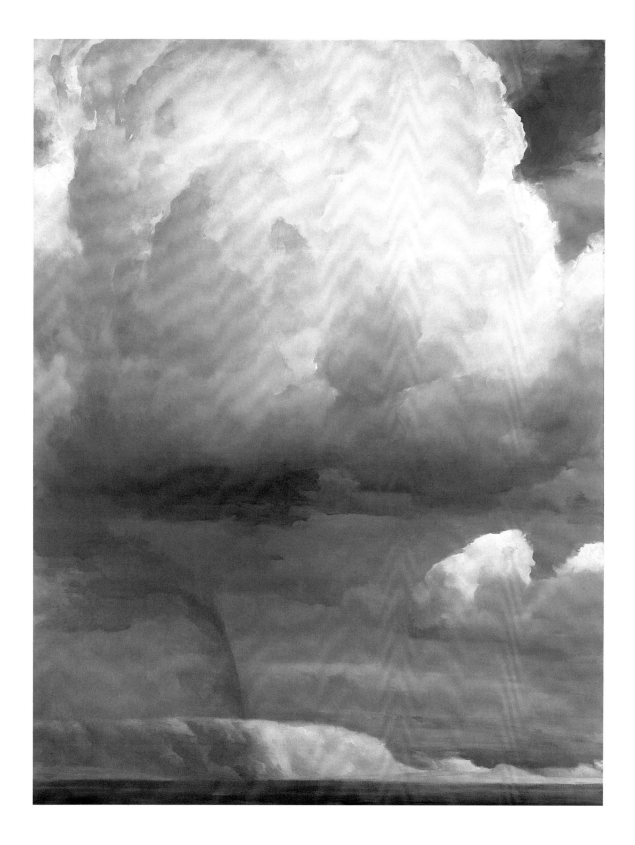

PLATE 21
*The Elements—Earth*
1982–84
Oil on canvas
96 x 75 inches (243.8 x 190.5 cm)
*Collection Mr. and Mrs. John J. Turchi, Jr.*

PLATE 22
*The Elements—Water*
1983–84
Oil on canvas
96 x 76 inches (243.8 x 193 cm)
*Collection Mr. and Mrs. John J. Turchi, Jr.*

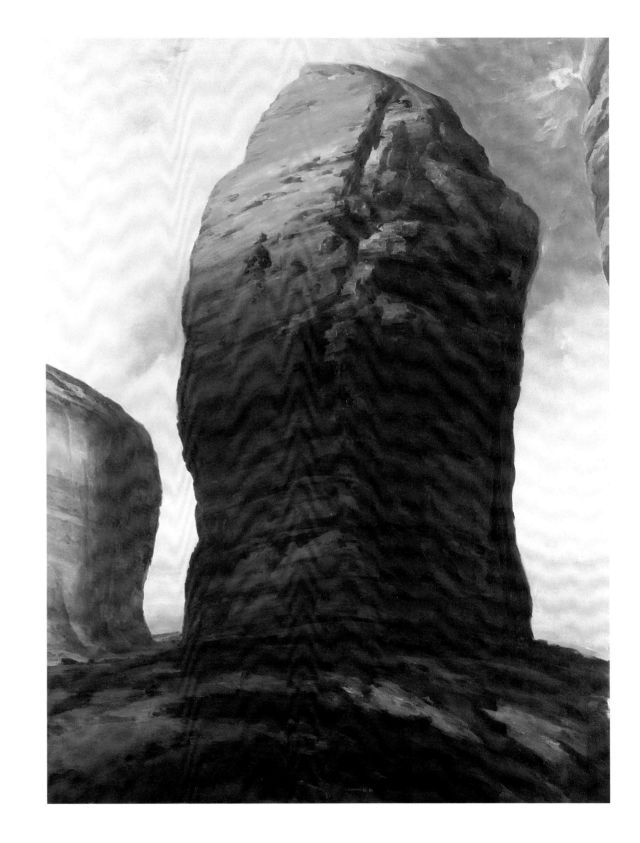

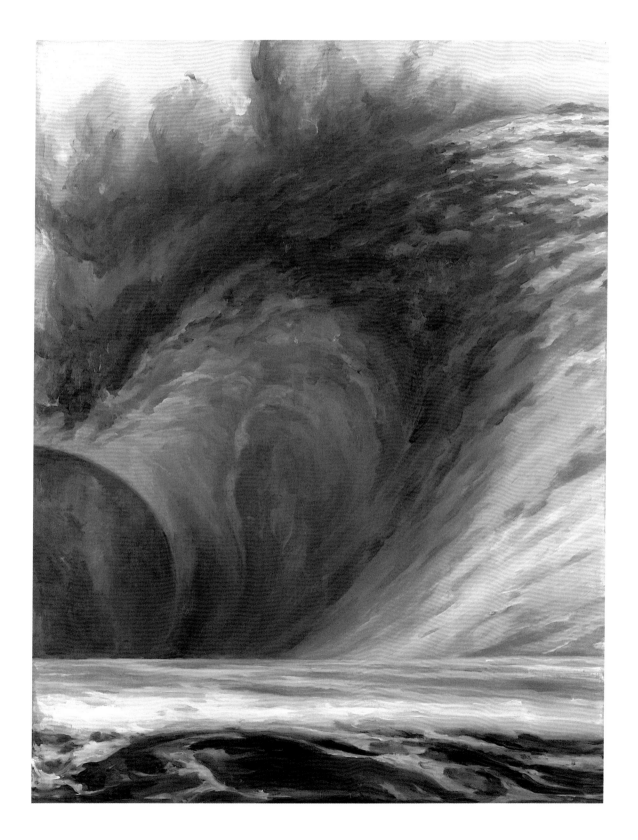

PLATE 23
*Man Against a Wall*
1980
Charcoal on paper
51 x 41½ inches (129.5 x 105.4 cm)
*Philadelphia Museum of Art. Gift of the Friends of the*
*Philadelphia Museum of Art. 1982-95-1*

PLATE 24
*Urban Lovers*
1981–84
Charcoal and pastel on paper
51 x 44¾ inches (129.5 x 113.7 cm)
*Terry Dintenfass, Inc., in association with*
*Salander-O'Reilly Galleries, New York*

PLATE 25
*Laocoon and Nun*
1983–84
Graphite on paper
29 x 46 inches (73.7 x 116.8 cm)
*Collection Dr. Thomas A. Mathews*

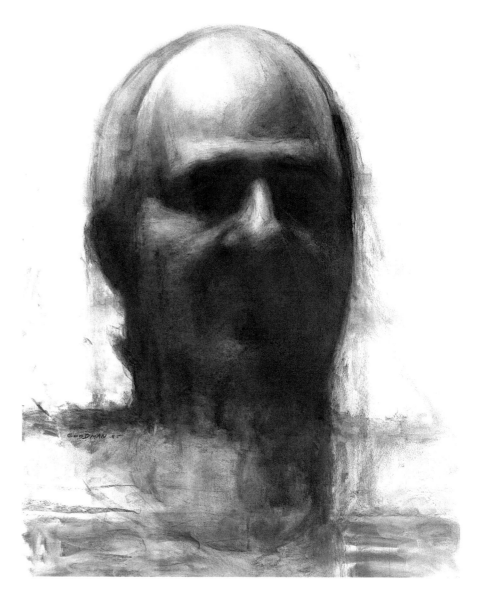

Plate 26 *(opposite)*
*Inside the Cage*
1984–85
Charcoal and pastel on paper
59 x 68½ inches (149.9 x 174 cm)
*Terry Dintenfass, Inc., in association with*
*Salander-O'Reilly Galleries, New York, and*
*The More Gallery, Inc., Philadelphia*

Plate 27 *(above left)*
*Self-Portrait—Red*
1985
Conté crayon and pastel on paper
29 x 23 inches (73.7 x 58.4 cm)
*Collection Frank and Betsy Goodyear*

Plate 28 *(above right)*
*Self-Portrait—Black*
1985
Charcoal on paper
29 x 23 inches (73.7 x 58.4 cm)
*Collection Frank and Betsy Goodyear*

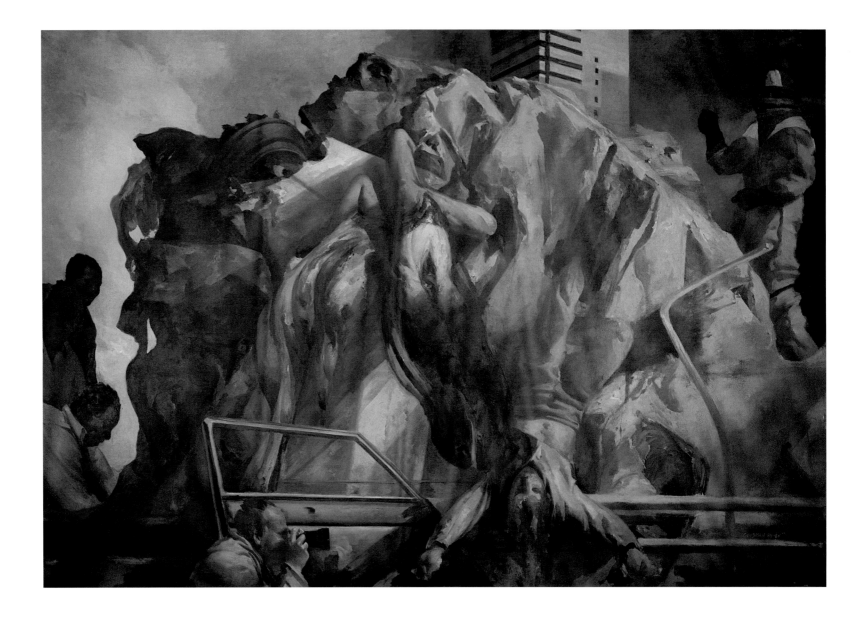

PLATE 29 *(above)*
*A Waste*
1984–86
Oil on canvas
89 x 128 inches (226.1 x 325.1 cm)

*Terry Dintenfass, Inc., in association with Salander-O'Reilly Galleries,*
*New York, and The More Gallery, Inc., Philadelphia*

PLATE 30 *(opposite left)*
*Study of a Man Hanging*
1986
Charcoal and pastel on paper
83½ x 59 inches (212.1 x 149.9 cm)

*Collection Andrew and Ann Dintenfass*

NOT IN EXHIBITION

PLATE 31 *(opposite right)*
*On the Ball*
1986
Charcoal and pastel on paper
91 x 59 inches (231.1 x 149.9 cm)

*Terry Dintenfass, Inc., in association with Salander-O'Reilly*
*Galleries, New York, and The More Gallery, Inc., Philadelphia*

NOT IN EXHIBITION

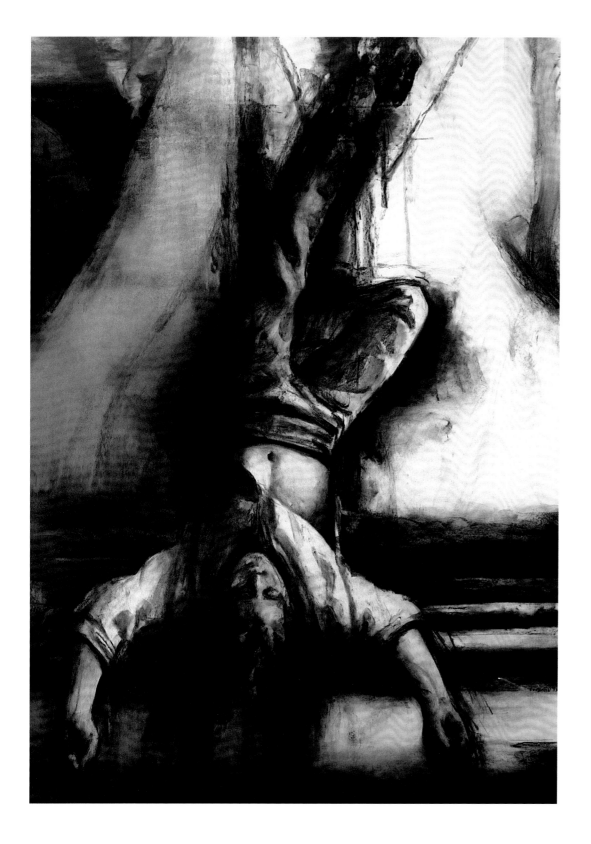

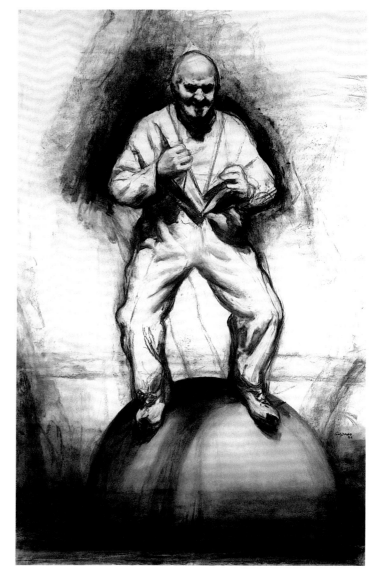

59

PLATE 32
*Night Burn*
1986–87
Oil on canvas
90⅛ x 67⅛ inches (228.9 x 170.5 cm)
*Wichita Art Museum, Wichita, Kansas. Burneta Adair*
*Endowment Fund*

PLATE 33
*Daydream*
1986–87
Oil on canvas
90⅛ x 67⅛ inches (228.9 x 170.5 cm)
*Wichita Art Museum, Wichita, Kansas. Purchased with funds*
*from the Friends of the Wichita Art Museum, Inc.*

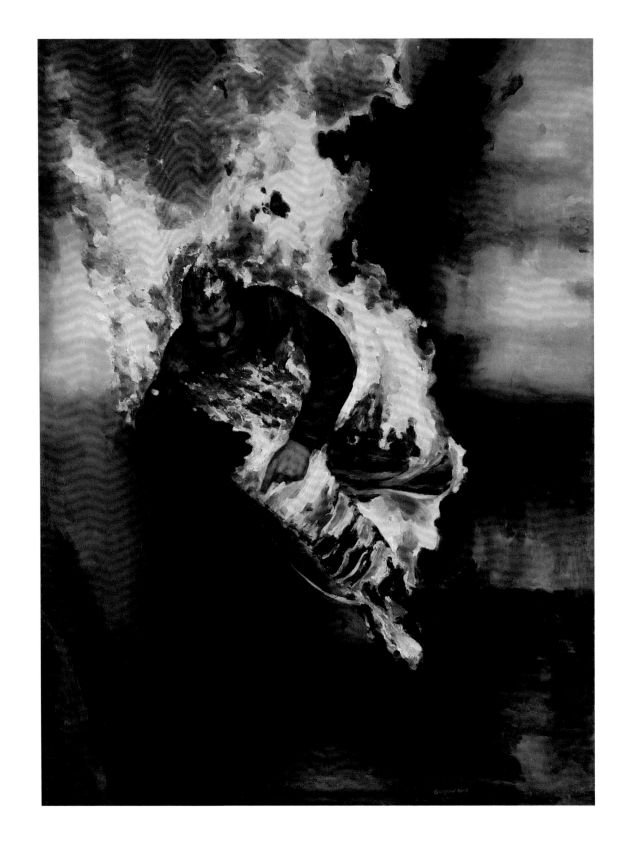

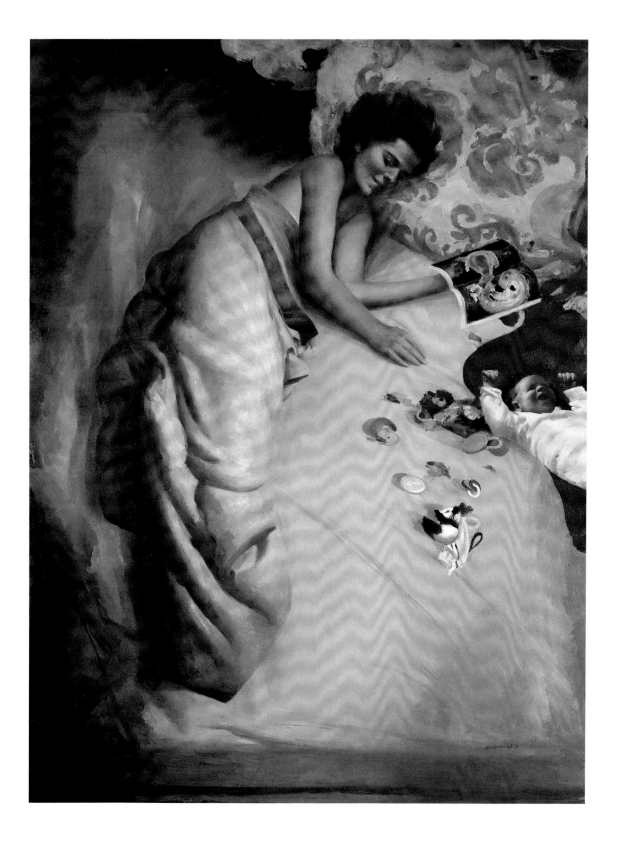

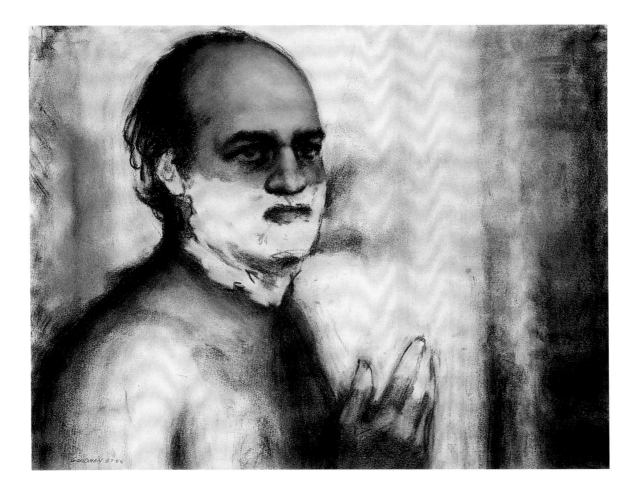

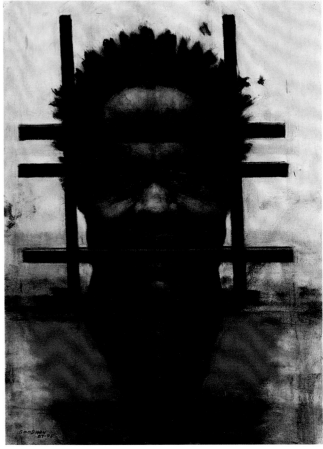

PLATE 34 *(above left)*
*Man in the Mirror*
1987–88
Charcoal and pastel on paper
22 x 30 inches (55.9 x 76.2 cm)
*Collection Malcolm Holzman*

PLATE 35 *(above right)*
*Study for "Political Prisoner"*
1987–88
Charcoal and pastel on paper
30⅛ x 22 inches (76.5 x 55.9 cm)
*Museum of American Art of the Pennsylvania Academy*
*of the Fine Arts, Philadelphia. John S. Phillips Fund*

PLATE 36 *(opposite)*
*Easter Sunday*
1987–88
Charcoal and pastel on paper
96 x 60 inches (243.8 x 152.4 cm)
*Allentown Art Museum, Allentown, Pennsylvania.*
*Purchase: The Reverend and Mrs. Van S. Merle-Smith, Jr.,*
*Endowment Fund, 1990*

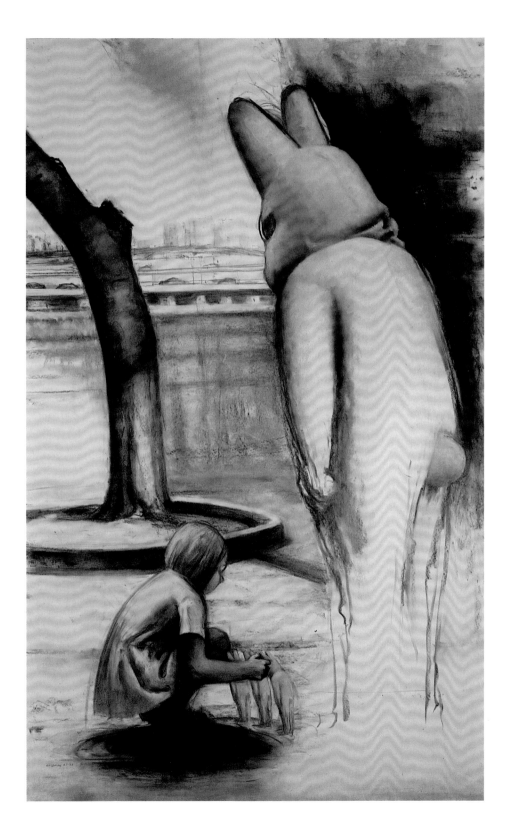

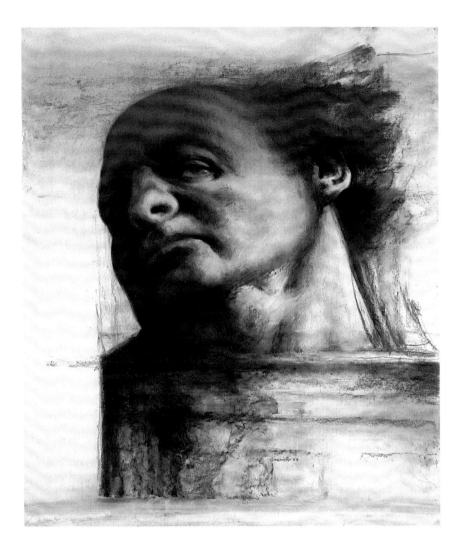

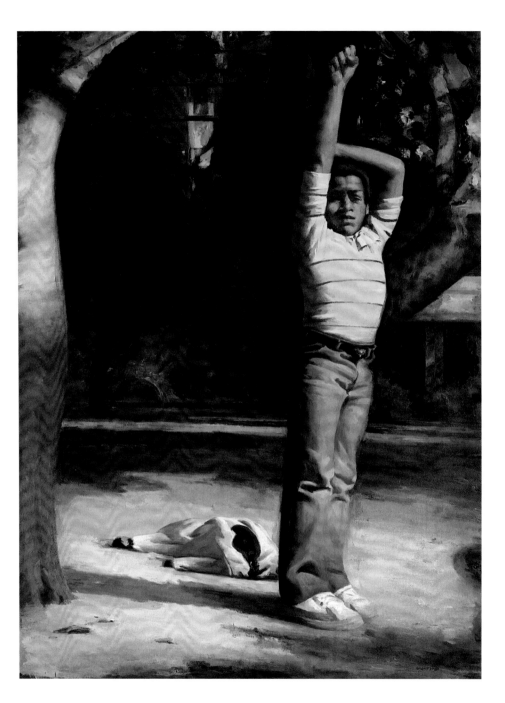

PLATE 37
*Head with Red*
1988
Charcoal and conté crayon on paper
65¾ x 59¾ inches (167 x 151.8 cm)
*Collection Nat and Georgia Kramer*

PLATE 38
*Boy with Raised Arm*
1988
Oil on canvas
103¾ x 77⅞ inches (263.5 x 197.8 cm)
*Collection Lynda and Stewart Resnick, The Franklin Mint,*
*Franklin Center, Pennsylvania*

PLATE 39 *(opposite)*
*Blind Singers*
1988
Oil on canvas
44 x 52 inches (111.8 x 132.1 cm)
*Philadelphia Coca-Cola Bottling Company*

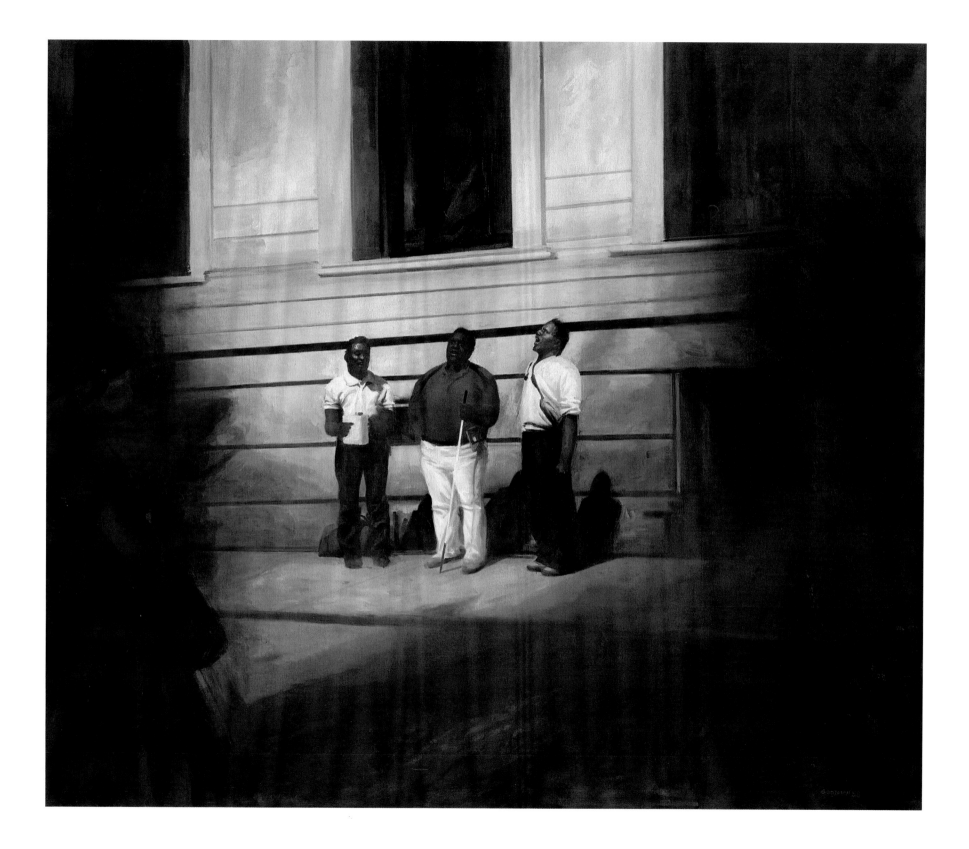

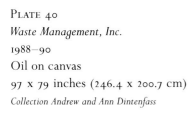

PLATE 40
*Waste Management, Inc.*
1988–90
Oil on canvas
97 x 79 inches (246.4 x 200.7 cm)
*Collection Andrew and Ann Dintenfass*

PLATE 41
*Day Break*
1989–90
Oil on canvas
87 x 78½ inches (221 x 199.4 cm)
*Collection Joseph D. and Janet M. Shein*

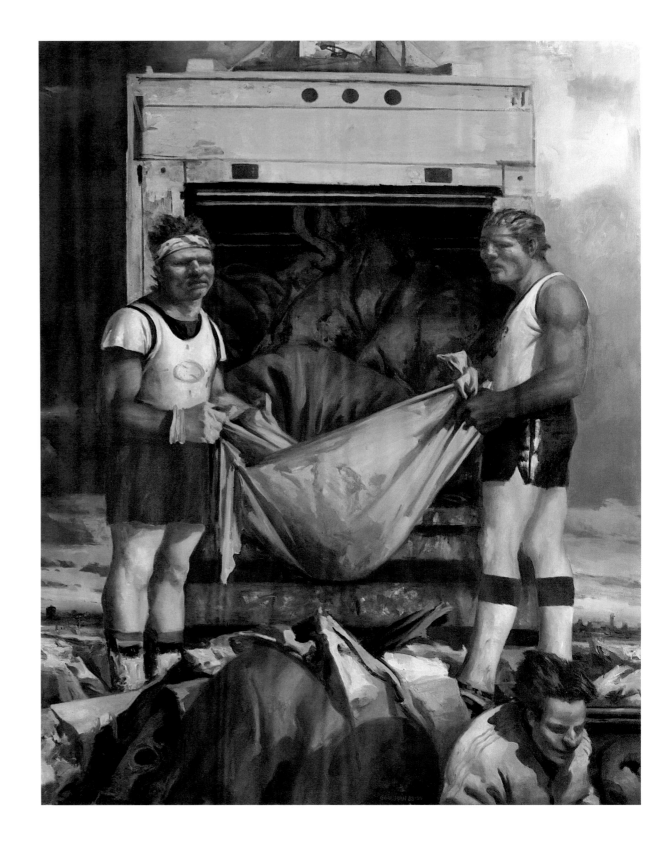

PLATE 42
*Landscape with Black Clouds*
1989–91
Oil on canvas
62 x 119 inches (157.5 x 302.3 cm)
*Terry Dintenfass, Inc., in association with*
*Salander-O'Reilly Galleries, New York*

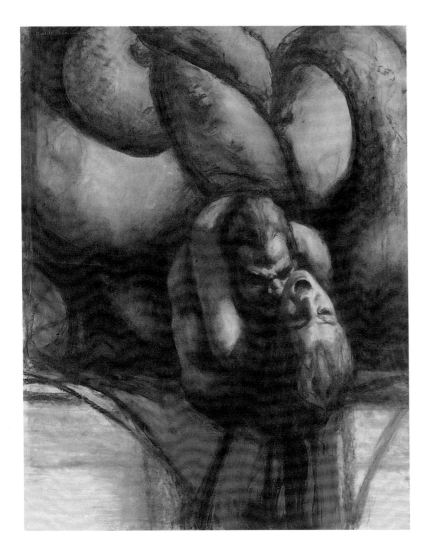

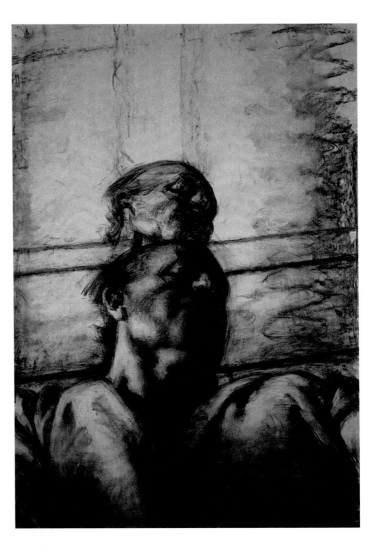

PLATE 43
*Love Knot*
1990–91
Charcoal and pastel on paper
59½ x 46½ inches (151.1 x 118.1 cm)
*Private collection*

PLATE 44
*Man with Afterimage*
1991–92
Charcoal on paper
55 x 39½ inches (139.7 x 100.4 cm)
*Terry Dintenfass, Inc., in association with*
*Salander-O'Reilly Galleries, New York*

PLATE 45 *(opposite)*
*Waking Up*
1992
Charcoal and pastel on paper
50 x 70 inches (127 x 177.8 cm)
*Collection Richard and Donna Burnett*

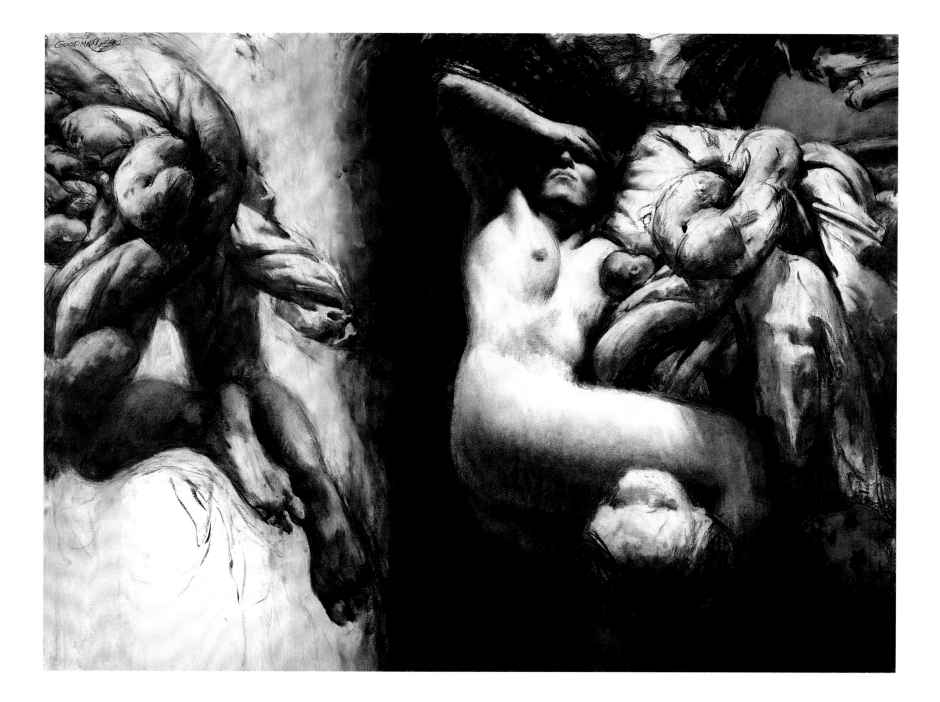

PLATE 46
*Free Fall*
1988–91
Oil on canvas
102 x 210 inches (259.1 x 533.4 cm)
*Terry Dintenfass, Inc., in association with*
*Salander-O'Reilly Galleries, New York*

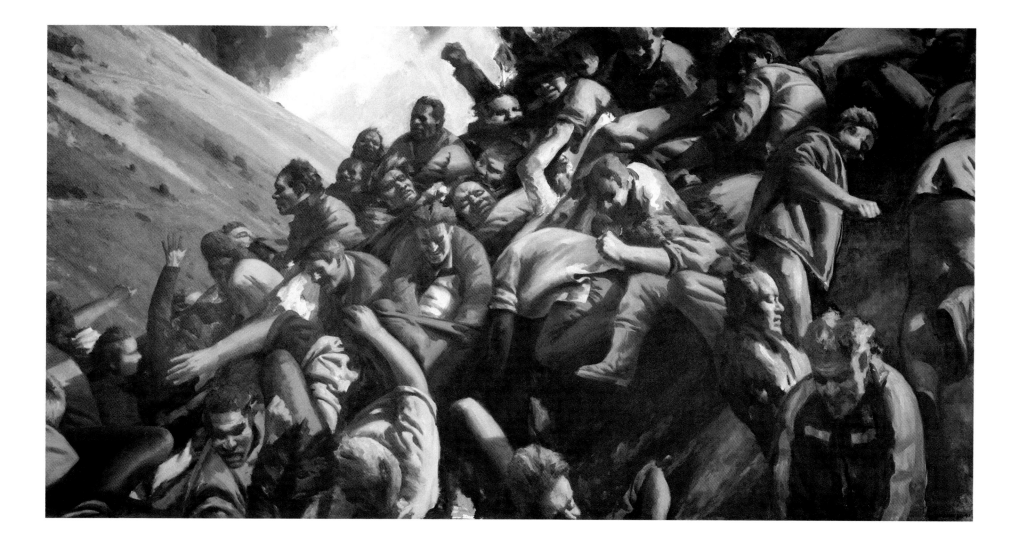

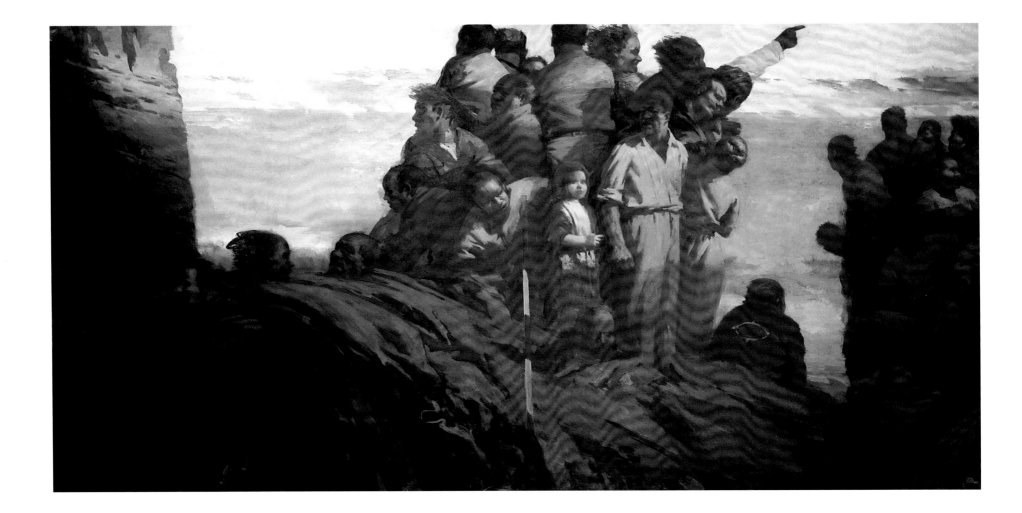

PLATE 47
*Transition*
1992–93
Oil on canvas
104 x 216 inches (264.2 x 548.6 cm)
*Pennsylvania Convention Center Authority, Philadelphia*

PLATE 48
*Sightseers*
1991–93
Oil on canvas
102 x 210 inches (259.1 x 533.4 cm)
*Terry Dintenfass, Inc., in association with*
*Salander-O'Reilly Galleries, New York*

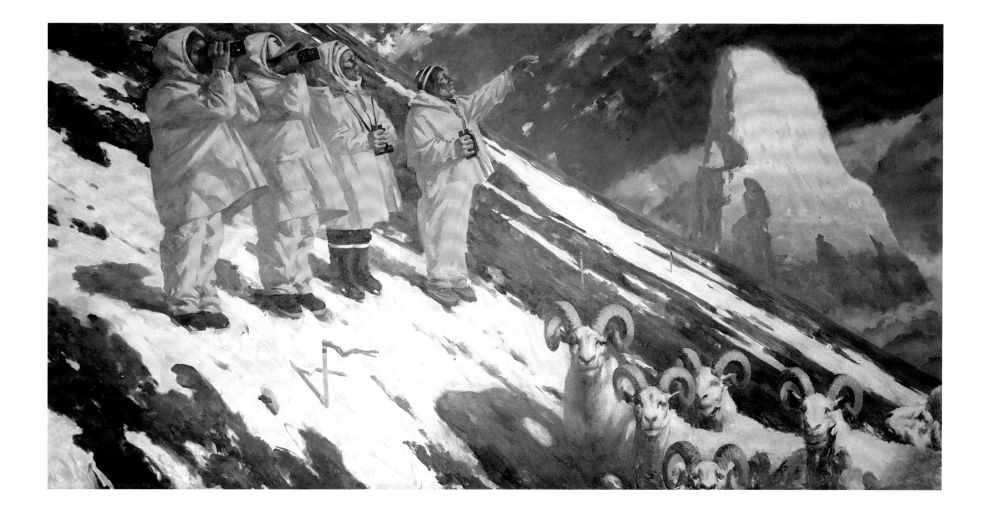

75

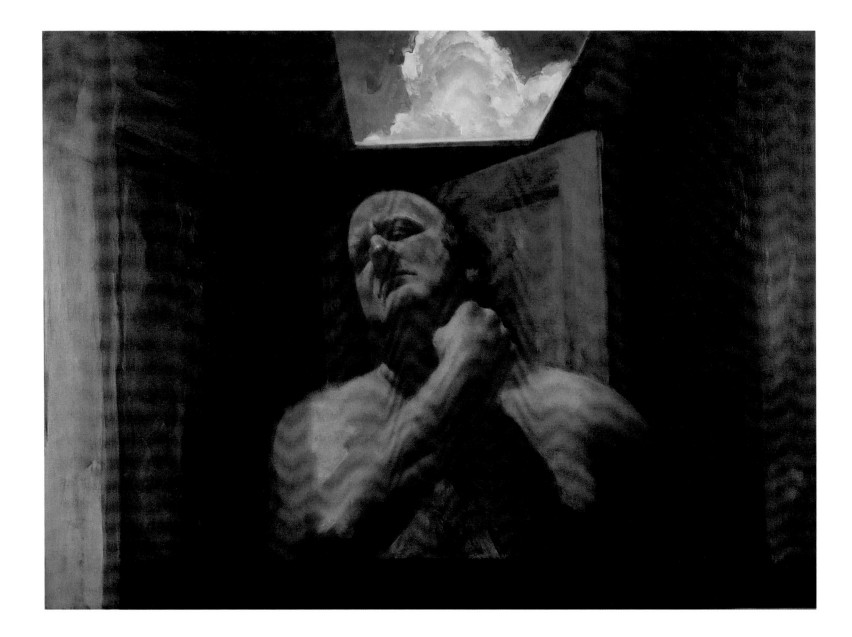

PLATE 49 *(opposite)*
*Self-Portrait with Arm Raised*
1993
Oil on canvas
34¼ x 47 inches (87 x 119.4 cm)
*Terry Dintenfass, Inc., in association with Salander-O'Reilly Galleries, New York, and The More Gallery, Inc., Philadelphia*

PLATE 50 *(left)*
*Bright Sun*
1988–93
Oil on canvas
66 x 54 inches (167.6 x 137.2 cm)
*Terry Dintenfass, Inc., in association with Salander-O'Reilly Galleries, New York, and The More Gallery, Inc., Philadelphia*

PLATE 51 *(above)*
*Artist's Mother I*
1994
Charcoal and pastel on paper
51 x 36 inches (129.5 x 91.4 cm)
*Terry Dintenfass, Inc., in association with Salander-O'Reilly Galleries, New York*

NOT IN EXHIBITION

PLATE 52 *(right)*
*Bloody Head with Fist*
1994
Charcoal and pastel on paper
29½ x 38 inches (74.9 x 96.5 cm)
*Collection Andrew and Ann Dintenfass*

PLATE 53 *(opposite left)*
*Woman Emerging*
1994
Charcoal and pastel on paper
59¾ x 35½ inches (151.8 x 90.2 cm)
*Collection Robin Green*
NOT IN EXHIBITION

PLATE 54 *(opposite right)*
*Demolition Site*
1994
Pastel on paper
46½ x 37½ inches (118.1 x 95.2 cm)
*Terry Dintenfass, Inc., in association with*
*Salander-O'Reilly Galleries, New York*
NOT IN EXHIBITION

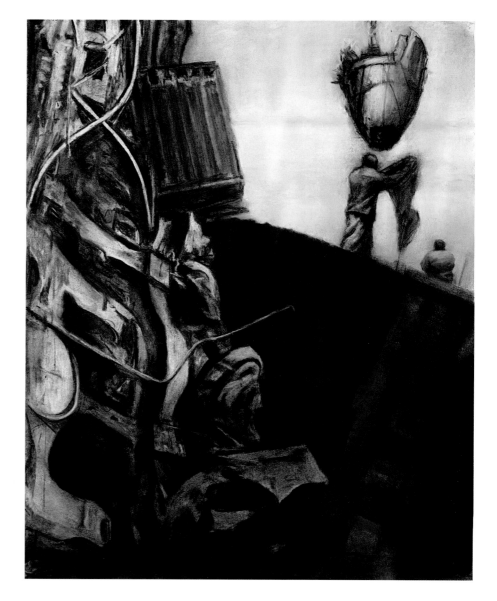

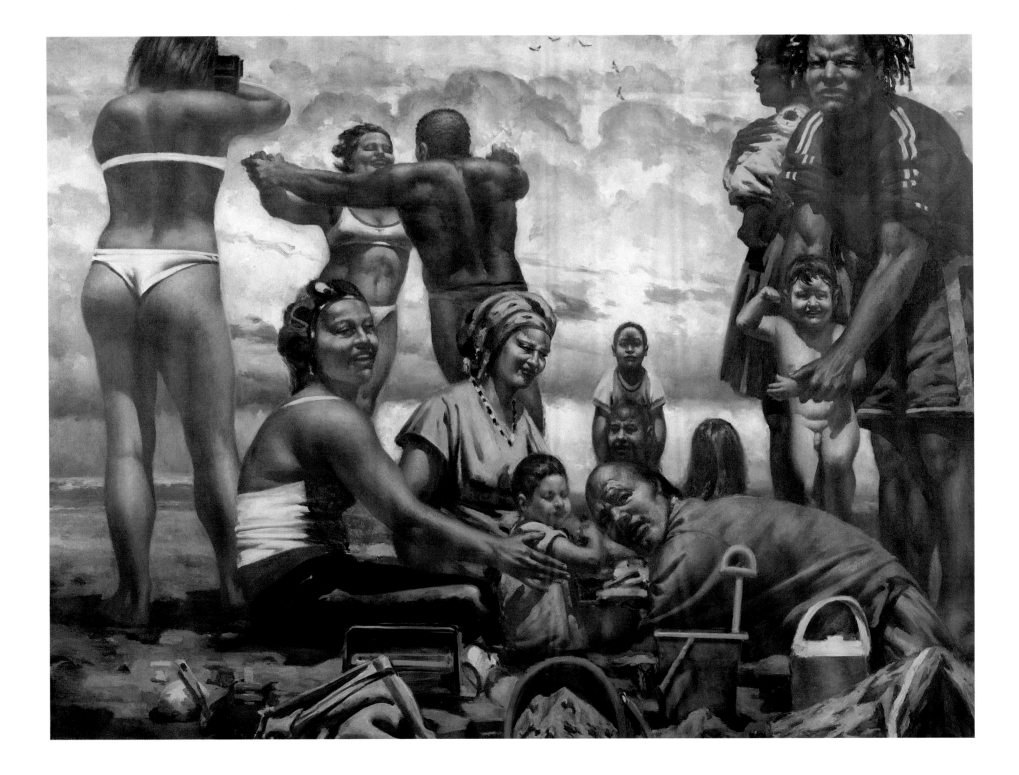

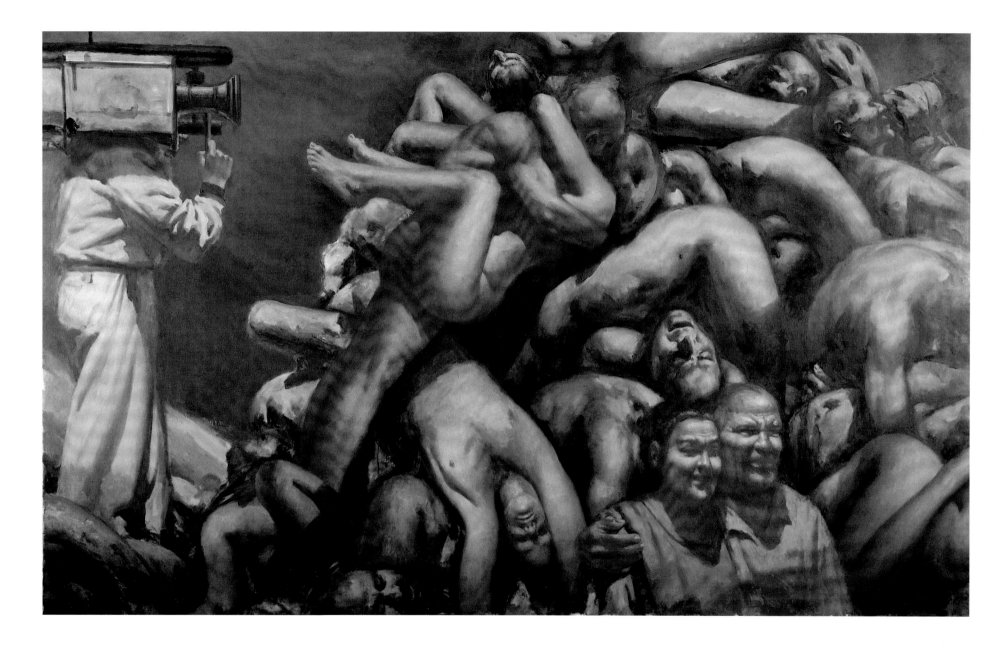

PLATE 55
*Vitas*
1994–95 (nearly complete;
photographed October 1995)
Oil on canvas
85 x 114½ inches (215.9 x 290.8 cm)
*Terry Dintenfass, Inc., in association with*
*Salander-O'Reilly Galleries, New York*

PLATE 56
*Spectacle*
1993–95 (nearly complete;
photographed October 1995)
Oil on canvas
76¾ x 124½ inches (194.9 x 316.2 cm)
*Terry Dintenfass, Inc., in association with*
*Salander-O'Reilly Galleries, New York*

# Interview

*Excerpts from an interview with Sidney Goodman conducted by Marina Pacini in Philadelphia in late October and early November 1990 for the Archives of American Art, Smithsonian Institution, Washington, D.C. The version here has been edited by John B. Ravenal.*

**MP:** Can you begin by telling me about your family circumstances—what your parents did, what your family was like?

**SG:** Both my parents came here in the mid-twenties, I think '26–'27, and they were in their teens. They met here. They came from Russia. They were in the large wave of Russian Jewish immigration during that period in time. My father had an older brother who was in the fur business—he was a storekeeper. My father came here with the idea that he would learn the business from his brother, and that, in fact, is eventually what happened.

**MP:** Your mother worked in the Yiddish theater?

**SG:** That was fantasy—that was her wish. She was always a kind of flamboyant personality; she was very interested in the theater. She was not a professional; she was an amateur. But I think she always wanted to be, and she performed here in Philadelphia at the YMHA [Young Men's Hebrew Association] and different union halls or theater places, in amateur theater. She also worked for my father as what was then called a finisher: when a fur coat was being made, she put in the linings. She helped my father, and he wanted and needed her help. Because of that, he kind of frowned at the idea of her being on the stage. In fact, according to my mother, I don't think he ever saw a performance.

**MP:** Did they have any interest in other cultural things? Were they at all interested in art?

**SG:** No. Not so much beyond Yiddish and Russian culture. That's the crazy thing. They were both proud of things that happened to me in regard to my career, but my father had never been to an art opening. I don't think he ever saw a show of mine, because I think he just felt out of his element. He thought if I was doing well, what would it matter? He didn't really care that much—as long as he thought I was doing well. But his interest in it was very little—was nil in a certain way. Once my mother told me he was upset over a drawing that I had done of him in front of his three-way mirror—we always had mirrors in my father's store. In fact, my father's store was like a little fantasy world. I used to go down there and play, and he had a big rug—the pelt of a polar bear—which was always on top of the safe with a gaping mouth with the teeth. I remember playing with the teeth when I was a little kid, and some of the teeth would come out. And these big vaults, and the three-way mirrors, the mannequins. And then he used to dress the windows. He used to outfit them in a certain way that always had a slightly surreal quality. In fact, a friend of mine saw one of his window displays and said to me, "Now I know why you paint the way you do."

**MP:** Was religion important in your family?

**SG:** Not at all. In fact, it was at times a point of contention. My mother would say some expression in Yiddish or Russian like "God bless this," and my dad would mock her in some ways. His parents wanted him, I think, to become a rabbi. When he came to this country, when he was on the ship headed for America, I think it was an act of rebellion for him to sell the religious sacraments—the tefillin and the shawl and things like that. The religion was replaced by communism. In fact, he had a great, romantic ideal all of his life about communism. We used to have arguments in later years. My parents took one or two trips to Russia when they were in their late fifties, early sixties, and my mother was able to see all of the things wrong with it. I mean, she had a clear-eyed picture, because they still had relatives there. My mother used to send clothing there. They used to send whatever they could to her brother and her brother's family, and she saw the way they were living there. She saw very clearly the anti-Semitism that existed. But my father, for some reason, just turned a deaf ear to it all.

**MP:** Besides just the religious aspects, were you inculcated with anything about what it meant to be Jewish?

**SG:** No. That's the thing that set me apart as a child, and I had a little anxiety about it with some of my friends, because they had all been bar mitzvahed and I hadn't. My father didn't want to send me to Hebrew School. He didn't want to pay for it, he didn't believe in it. He thought it was all bullshit, and, so, I didn't go and I wasn't bar mitzvahed

when all my friends were. And the friends of my parents, and my friends themselves, would say, "Well, you are not even a Jew." My parents were very Jewish in regard to culture, but they were political rather than religious.

**MP:** When did your interest in art start?

**SG:** I think I always drew a little bit. I fooled around when I was a kid, but I was never encouraged. I remember in sixth or seventh grade, I think I felt confident in drawing. I think I used to draw a lot of the things that I wanted. If I wanted a baseball glove, I'd draw it. If I wanted a cap gun, I would draw it. If I liked some girl, I would try to draw her, when I was a little older.

**MP:** You were hoping to play professional baseball as a young man. At the end of high school was it a big issue for you, whether it was going to be art or baseball?

**SG:** Not really, because in my senior year I hurt my knee. I got kicked off the baseball team. I didn't get into West Chester State Teacher's College, which is probably the most pivotal thing. I thought I was going to go there to become a gym teacher. The summer that I graduated high school [1954], I did a lot of drawings. I copied things out of books; there was a whole variety of things. I thought the more different things I could do, the better off I would be. I didn't even have a portfolio. I had this sketchbook, filled with things. I put it in a

brown paper bag, and I took it to the Philadelphia College of Art [PCA].

**MP:** Did you ever consider the other schools in town, like the Pennsylvania Academy of the Fine Arts?

**SG:** No. I think because I thought PCA was mostly a commercial art school. They didn't have a fine arts program. They didn't have that until about the mid-sixties, and I graduated in '58. But my parents pushed me to go there, because they thought I could be in commercial art because I could always draw. I didn't know there was a distinction between commercial and fine art. I thought it was all the same. I mean, that's how innocent I was in regard to cultural things or painting in general. But I realized once I was in school that illustration, in a way, doubled as a fine arts program. Because if you took illustration, you had drawing and painting and printmaking electives. And that was great. And I was really revved up. I had teachers like Larry Day, Albert Gold, Jacob Landau, Morris Berd—and they all encouraged me.

**MP:** Tell me about each of these teachers, about their philosophies or teaching methods, their influence on you. Let's start with Jacob Landau.

**SG:** He was partly a commercial artist, and partly a fine artist, and he was very encouraging to me. In fact, we traded prints when I was in school. I had illustration with him. Larry Day was very strong—I mean, he was a real painter.

He was more philosophically questioning. He made you think more about the nature of larger issues. He was always questioning things, and he really probed and made you question what you were doing and why you were doing it. So he kind of made me, and others who were receptive, more intellectually aware. Morris Berd was also an Abstract Expressionist painter, who went back and forth between realism and abstract painting, but in those days it was abstract. And he was more basic. He talked more about the painting—more about the working out of the painting—the mechanics of it. I had some drawing courses with Albert Gold; Jerry Kaplan in printmaking was very good.

**MP:** I understand that Franz Kline was at PCA in the fifties.

**SG:** Yes. Just before I got there. I had heard about it. Larry and Morris knew him. I think they went out drinking with him a couple of times.

**MP:** Did these artists who were teaching there work on the premises? Did you have access to their work?

**SG:** No. My last year of art school, Larry and I got friendly—well, Morris and Larry both became friends in my last year of art school. I think they probably knew I was really headed towards being a painter, and they were encouraging. But you see, when I was in art school, I did a lot of illustrations—my parents, they wanted me to do illustration. So by the time I graduated art school, I had two portfolios. One was

of all the stuff that I did on my own, that I had an interest in doing, that was not dictated by some illustrative problem, and the other was the stuff in illustration. So, I had a pile of prints, drawings, and paintings, and an illustration portfolio. And I thought, to make money or to please my parents, just so I could make a living, I thought maybe I can do illustration and then paint after that. The first job I got was to do an album cover of Duke Ellington (fig. 34). And I did that and my parents were thrilled because I got $350 for that—full color—and it was a collection of some of his best hits. But the thing was, when I did this cover, I tried to do it in the way that I paint. It was in an expressionist manner, and he had red veins and stuff all over his face, and it was like a wild kind of a head. And it wasn't right; I had to do it over again. They said, "No. It's still too much. You got to take this out, take this out." So, I did it over three times just to get the money.

Figure 34. Sidney Goodman. Cover of *At His Very Best: Duke Ellington and His Orchestra* (Collector's Series, RCA Victor, 1959)

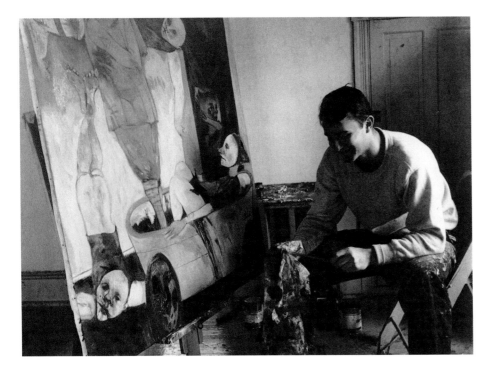

**MP:** Can you remember which artists' work that you would have seen during this period that had some impact on you?

**SG:** I went through different periods of things. I liked De Kooning, Gorky, Soutine—I mean, there were so many people whose work I was attracted to. In my last year I think Van Gogh and Soutine were interesting to me. At the same time, a lot of Renaissance. I was interested in many different things, which is natural for students. And after a while, you hone your vision down to people that seem to fit more with your temperament, in regard to your work. I think my early work reflected the work of George Grosz. I was looking at Ben Shahn a little bit, but not that much. Ben Shahn

was an influence on Jake Landau and that was transmitted through him. Some of my illustrations maybe had a little Ben Shahn influence.

**MP:** Were you looking at all at Francis Bacon?

**SG:** Well, that came later. I was out of school by then. People have mentioned Bacon, but I wasn't directly influenced by him. I mean, I liked his work, but I was interested in Muybridge photographs, and that's where the connection is. A lot of Bacon's early things were based on Muybridge photographs, and I used those in my early work. I used them in a different way—a more naturalistic or realistic way.

**MP:** Were you aware of the fact that Bacon was interested in Muybridge?

**SG:** Yes. I would look at his catalogues and things, and it was often mentioned. They'd show the actual pictures that influenced him. But I got it through the Muybridge books, so I was actually looking directly at Muybridge, as he was. Some Muybridge photographs were shown at PCA—either in my last year of school or in the early sixties.

**MP:** I know that Morris Berd was interested in Balthus, Hopper, and Morandi. Were you also?

**SG:** That came about a little later, after I was out of art school. When I was in school, it was De Kooning and Pollock and Franz Kline. That was the main interest. Because Larry Day and Morris Berd, they were teaching it. They were abstract painters at that point. They kind of went back to realism or a naturalistic approach in the early sixties.

**MP:** What did your art look like while you were in art school?

**SG:** Well, there was a mix of things. It was expressionistic, it was semi-abstract. In my last year, I started working from my imagination. And that's in some of the early things I did, just before going in the Army in 1958 (fig. 35). They had a kind of a social comment in them.

**MP:** You called them your "new images of man" type of works in one place.[1]

**SG:** Yes. They were a little more like that. They were more expressionistic, more fantasy oriented, and all of that was coming out of my head. But I was

dissatisfied with that. I still had the great examples of Renaissance painting in my mind. Even though I was doing those things, I was looking at heads by Titian and Rembrandt, Velázquez, Vermeer, Goya. The biggest core of influence back then was the two Dutch and two Spanish painters.

**MP:** You said that when you walked out with your portfolio after school, there was a big difference between the illustration work and the work that you did on your own.

**SG:** In my own work, I did whatever I wanted to do. With illustration, I tried to do the best I could do, given a situation. When I had these illustration jobs, that's when I realized for the first time that I couldn't do whatever I wanted. I was told that I had to compromise. And, you see, my nature is more uncompromising, and everybody knew it. My painting teachers knew it. And then when I went to Yale-Norfolk in the summer of '57, that's when I knew I really wanted to paint.[2] I didn't want to do illustration.

**MP:** How much did you know about and what did you feel about some of Philadelphia's many painters? Were you at all interested in Thomas Eakins? Or Andrew Wyeth?

**SG:** Well, I remember in the lunchroom at PCA, some of the guys in illustration, they wrote to Wyeth and they actually went out to visit him back then. And they asked me if I wanted to come and I didn't go, and they came back and

Figure 35. Sidney Goodman in his studio, 1958

they said, "Oh, we went in this guy's house. It was incredible." They saw his studio. They said, "Oh, you would have liked it." Actually, I had a show at the Peale House in 1968–69, and the show was just hung and Wyeth and his son Jamie came in and they were looking at the stuff. And I was sitting in a room with them and there was a guard there and I didn't say a word. So the guard said, "Why didn't you say something to them?" I just didn't feel like it.

**MP:** In 1971 Terry Dintenfass made a statement about her gallery, and she said that "the gallery's aim was to be a forum for artists reflecting man and his involvement in the world. Man's inhumanity to man." Do you feel like that reflects your interests?

**SG:** Terry's artists have always had a strong human or existential concern, or always dealt with, to use the old term, the human condition.

**MP:** Have you always felt comfortable being included in that group, with Ben Shahn, Philip Evergood, Robert Gwathmey, Jacob Lawrence?

**SG:** Well, I tell you, I always felt that they were of another generation, probably the same way that people maybe look at me now. I guess, I felt my work wasn't in a time slot like that, or that I didn't really have that much connection with them. I felt in tune more with other people's work. I liked a lot of the Europeans. I liked Giacometti, Picasso, and Balthus—some people like that.

**MP:** How did your trip to Europe in 1961 come about? Terry's memory was that a client of hers, Dr. Abraham Melamed, said that he would give you some money and that you would just spend a year painting, and that she then talked to Jack Levine and he said, "Send him to Europe."

**SG:** Yes. Dr. Melamed agreed to send me to Europe with the condition that he would choose two of the paintings on my return that were inspired from the trip. We—my first wife Eileen and I—had an itinerary that Morris Berd had used, and he told us all the places to go. It was a great itinerary. Just all of the Velázquez at the Prado knocked me out. Goya's black paintings—a lot of my early work, I forgot to mention, was influenced by Goya heavily. Especially early in my career, it was tending that way, with the kind of grim view of things. The Velázquez *Las Meninas* painting—I think I spent about an hour and a half just looking at that painting, and we came back the next day. That really knocked me out. And a lot of Vermeers and Rembrandts. Rembrandt and Goya and Velázquez were really the ones.

**MP:** You were starting to say something else about the "new humanism"?

**SG:** Well, I'm always suspicious of the "new" this and the "new" that. But, when I was getting started working—getting out of school in the late fifties, early sixties—there was a "new humanism." And my teacher Jake Landau was

aware of it, and he knew the sympathies of my work kind of fit in with that. There was a book that came out called *The Insiders* by Selden Rodman, who was a poet.[3] And previous to that, the *New Images of Man* exhibition. Nathan Oliveira was in that show. James McGarrell, De Kooning—a mixed group of people. Some very well known; some unknown. I was very well aware of that show, because I was just getting out of school—just about to go into the Army, and all of this stuff was happening.

**MP:** Did you see *New Images of Man*?

**SG:** I didn't see it. I saw the catalogue. I think I was in the Army when it came out. I was very interested because I felt in sympathy with it. And because there was a kind of a ground swell for that kind of work. The show that Alfred Barr put together at the Modern in 1962, which I was in—*Recent Painting USA: The Figure*—that was an open-juried show.[4] He was kind of like tapping, it was like a weather vane sent out. In that show, hanging across the hall from my work was Tom Wesselmann. A few pop figures were in that show. I'm not sure if Warhol was. But anyway, when that show came about, there were some people who were in it and some people who were excluded. People like Alex Katz and Philip Pearlstein were not in it; Chuck Close wasn't on the scene yet. He was probably still in school. So it was just in the beginning of the sixties. I was only twenty-six, and I was just

chosen from the slides or whatever it was that Terry Dintenfass submitted. So, for me, that was the big break. There was talk about a new kind of humanism, and it was that generation getting a foothold, getting started. But in the art world, there were people like Fairfield Porter and Alex Katz who were reacting against this trend, because they were a little more painterly, they grew out of Abstract Expressionism. They were objecting to the new humanism, because they thought it was going to be a lot of angst and Sturm und Drang, and they were a little more like what you might call "Ivy League realists." It's kind of a pejorative term, but they didn't have any of what you call a strong humanist position. The humanist position can be just as corny, just as bad as a very aesthetic, ivory-tower kind of aestheticism. Too angst ridden, and it's sort of like romanticizing the dark aspect of life, as opposed to the opposite—that kind of becomes just a cold process.

**MP:** Where do you see yourself fitting into that spectrum?

**SG:** I don't fit in solidly with either one, because I think my work, in a certain way, accommodates both. There are times when I work according to the mood or the experience that I'm in, and if I feel like doing something that is really grim and gory, I'll do it. And at the same time, if I feel like doing something that is more lyrical or whatever, I'll indulge myself that way. Some people

who don't like my work might say, "Well, he lost at both ends."

**MP:** I'd like to discuss your techniques and working methods. When you set out to make a painting, do you usually do preparatory drawings first?

**SG:** I don't have any one set way. I probably work within an area of about three or four different approaches. Sometimes, I might be concerned or obsessed with an idea—something that comes into mind, and I'll just do it. Or I'll make sketches first—little sketches—and start painting. And sometimes the idea will be there, but I need the clarification of that idea, so I'm always cutting out photographs and clipping things from magazines and newspapers (figs. 36 and 37). I just have tons of stuff. So, sometimes a painting can be based on one photograph or several photographs, or it can be based solely on an idea that I have, and I have to get other things to help me clarify that, or translate it into a painting. So, it's a mixture, and the mixture isn't always the same.

**MP:** What happened in the late seventies in terms of the size of your work? Obviously you made some sort of conscious decision to work larger.

**SG:** A lot of it had to do with the fact that I never had a big studio. I worked as big as I could on the wall that I had, which was a converted bedroom in Elkins Park. So that even on that wall— say that wall was like ten feet or eleven feet across—I tried to work as large as I could, and I guess that was a conscious thing. But there was no way I was really able to do it in a small house.

**MP:** Well, once you made the leap, what happened? You've continued to work large, so obviously, you are enjoying it.

**SG:** Well, I think I said earlier, that summer I was in Yale-Norfolk, it's like I always thought, "Boy, it would be great to do big figure paintings." I like really being engulfed, surrounded—I like that. But also, I'd be in the mood to do something small. So, I'll go back and forth. Again, it's according to what I'm motivated by or what I feel like doing. Sometimes I'm in a mood to do a very delicate little thing, and sometimes you just feel like breaking out.

**MP:** Let's talk about color and the changes that you have gone through in your use of color.

**SG:** Well, I guess the changes in color also go along with the three developmental stages in my work. In the earlier work, which was, as I had mentioned, more expressionistic, the color was a little wilder, a little bolder, more varied. When the work started getting more realistic, the colors became more subdued, when I was looking at Renaissance painters and looking at Vermeer. The palette got very cool and pearly (see plates 6–10). I was interested in pearly light. Then I started changing to kind of a warmer, late afternoon light. It's funny, because, at the moment, the biggest painting I've done, I have at the studio—the painting is about seventeen and a half feet long. The whole section on the right is monochrome, dark, but it's a transition to very warm, bright color on the left. The reason for this is that the color is part of the idea. It's a

painting of a group of figures falling. The tentative title, let's say, is you can just call it "Falling" (*Free Fall,* plate 46). It's almost as if the painting is divided between night and day. I guess I was interested in the idea of figures moving from one atmosphere, or one realm, to another.

**MP:** Have there been major changes in how you've actually applied the paint to the canvas over the years? Is that tied into the different subject matter changes?

**SG:** Yes. But I think when my work cooled off, and became more overtly classical, the paint maybe wasn't quite as heavy. It was a little more refined. It was smoother. Which it still is in some ways. The painting I did of *Fire* with *The Elements* (plate 19), that's fairly thickly laid on, but it's not like an inch thick. It's just a little more impasto. The paint isn't as thin now.

**MP:** It seems like the texture of the canvas frequently comes through.

**SG:** Yes. It's not always regular. Some areas of the canvas will show more, some are moderate, and some are filled in with areas of thicker paint or more loose brushwork. I think in recent years, the surface has loosened up more. But even there, certain areas are loose and some are more together, which has to do with what interests me visually— why I choose to dig into one area and really do something subtle with it, or dig in a more realistic way. And other areas will be more loosely painted. I like that

difference, because I think it makes the surface more variable or more varied, the way things are.

**MP:** Have you always worked from the model or just at certain particular points in time?

**SG:** Different times. I haven't been working directly from the model in years. When I'm teaching at the Academy and I set a pose up for the students, I often draw in my sketchbook during class, or I'll take Polaroids. I'll often work from Polaroids and develop them into something. What I'm interested in doesn't reside in having to have a person in front of me. A lot of it is an imaginative way of interpreting or seeing something. So, I don't need to have to look at the model all of the time. I can look at the model part of the time, and work from photographs or just work out of my head.

**MP:** Did you study photography at PCA?

**SG:** I took a photography course. But I use a battered old Polaroid, which I got about 1963. It's a beat-up camera and it's just black-and-white, so when I look at black-and-white Polaroids, I'm making up the color.

**MP:** And that was when you first started taking your own photographs?

**SG:** Yes. I've just been using Polaroids. Because by having somebody pose, I can tell them to do something, take a shot of it, look at it, and change it. I was at the University of Houston in '79, and my friend George Kraus, the

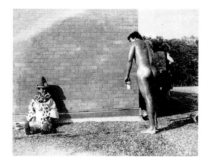

photographer, was there. He had his photography class on a roof. He had a clown—a midget—and a couple of nude models. I took photographs, and I still have some of them and occasionally I refer to them. There is a drawing of a guy against a wall (plate 23)—a naked guy against the wall—and I had the guy pose like that (fig. 38)—like he's being frisked by the cops or—I forget what position— but I made the guy stand against a wall.

**MP:** Am I seeing some references to the Crucifixion here as well?

**SG:** Well, I thought of both things. I like when something has more than one implication. A guy against a wall— he could be a prisoner, he could be up against a firing squad, but there is also a suggestion of something religious, as well as being contemporary. So, there's another implication. Sometimes when I'm doing something, it is not a premeditated thing. I mean, often it's like something that I might think about after the drawing is done, or when I'm halfway through it or almost finished it. It might be partly in my mind. But it's not like I set out to do all of these things beforehand.

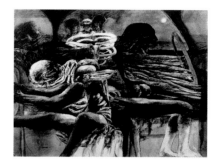

**MP:** Had you been working from clippings before 1963, when you started the photographs?

**SG:** When I started using photographs, that's about the time when the work got a little more ordered, classical. More refined. More realistic. Before that, it was all made up. I was working purely from the imagination, from the late fifties until I started working from the photographs about 1963. Up until then, I was using a model, working from memory, making things up. And I didn't know it at the time, but I was moving towards something more objective, something more verifiable, in terms of reality, the way things really looked. But I hadn't found the means to do it, and the Polaroids helped me. They helped the imagination. So that when I was using them, it was more of an aid. It's almost like looking at a sheet of music and being able to improvise on it.

**MP:** I wanted to ask you about some individual works. Your early drawing, *The Longest Ride* (fig. 39), is this one of the ones based on the impact of the car accident?

Figure 38. Sidney Goodman. Polaroid for *Man Against a Wall* (plate 23), 1979. *Collection of the artist*

Figure 39. Sidney Goodman. *The Longest Ride,* 1960. Watercolor on paper, 22 x 29½ inches (55.9 x 74.9 cm). *The Collection of Philip J. and Suzanne Schiller—American Social Commentary Art, 1930–1970*

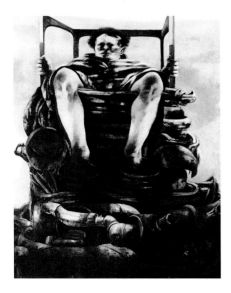

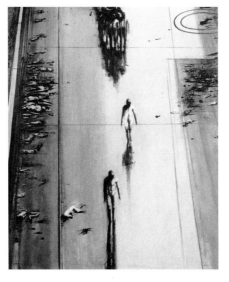

**SG:** Right. It was like a whole group of imagery—a group of paintings based on themes of cars, automobile parts, piles of automobile parts, and accidents and highway iconography (see fig. 40 and plates 16 and 29). I think that goes back to an experience when I was in a car accident when I was younger—in my late teens. I was in an accident in my last year in high school. I was thrown out of the car, and I was in the hospital for about three days just for observation. But anyway, it was things like that—even when I was a kid, I ran across the street and almost got hit by a car—or seeing my friend get hit when I was six or seven. These were early, youthful experiences that stuck in my mind, and the drama of those moments, I guess, fed into my imagination, and these images came about later.

**MP:** So you were working from things that were coming out of your own experience, not really trying to make any comments about the alienation of man and—

**SG:** Well, people always read— I mean, that's what people, a critic, could draw conclusions from. They were what they were, according to what I was thinking and what was coming out of me. I wasn't setting out to do "image of man"–type paintings or making pompous human comments or dramas. I was doing what seemed right and natural, according to my own experience.

**MP:** What about something like *The Walk* (fig. 41)? I can't imagine that you really experienced—

**SG:** No. That was based, partly, on a news clipping, on a photograph. A black-and-white photograph.

**MP:** Was it a Holocaust photograph?

**SG:** No. I think it was a Hindu and Muslim war. It was a news photograph. It was black-and-white, and I made up the color, but it was based loosely on that.

**MP:** I seem to remember having read that you said you were really affected by the photographs of the Holocaust.

**SG:** I saw those in *Life* magazine, along with probably many other kids my age, when I was about nine or ten years old.[5] My sister may have gone out once with somebody who survived one of those things. It was a shocking thing that the world was waking up to. It was the first inkling that anything like that had gone on, and being Jewish, it had more impact because you realized with a slight change of location and I could have been there. My family—we could have been there. So, that had a powerful effect, and I think I didn't want to deal with that directly, but that kind of horror, that kind of a nightmare, in a general way, probably it affected me. And implications of that—that darkness, that nightmare vision—often crept into the work. So I was attracted to that kind of thing.

**MP:** One thing I'm intrigued with is the way that certain imagery you work with recurs over an extended period of time. You continued to rework some of the themes.

**SG:** Well, that often happens. I'm working on a painting and sometimes a person or a figure from an earlier painting will be inserted, or I'll draw on things that I've done before and put it in a different context or a newer context (see fig. 42 and plate 25). That's one of the reasons, I think initially, I probably

liked painting because I had the freedom to do things like that. And you are working alone. If you are a musician, an actor, you are part of an ensemble, and it's a group thing. With painting, I could make up my own world.

**MP:** You've been described as a painter of death and pornography. Do you want to respond to that?

**SG:** Where did you get that from?

**MP:** I can't remember.

**SG:** I don't think—

**MP:** There are certainly many death images.

**SG:** Yes. Well, they are two Freudian things—sex and death are the big themes that are ancient and contemporary and that everybody uses. I'm certainly not the only one that uses that.

**MP:** In a lot of the literature that I've read, everybody talks about the death imagery in your work, but there is no discussion of the sexuality.

**SG:** I don't know how you can divide it up, but I think they probably would be equal. Images that in some way, either directly or indirectly, relate to the termination of life, to death and things that— I mean, it's like night and day—sex and death. Sex is the life force, and the other is the opposite.

**MP:** Do you see yourself as participating in this long art historical tradition of treating the nude?

**SG:** Yes. Sure. I'd have to be. Anybody who paints the nude is dealing with an ancient theme, before the Greek and

Figure 40. Sidney Goodman. *Man on Top,* 1961. Oil on canvas, 60 x 50 inches (152.4 x 127 cm). *Collection Mrs. Sol Kahn*

Figure 41. Sidney Goodman. *The Walk,* 1963–64. Oil on canvas, 83½ x 65¼ inches (212.1 x 165.7 cm). *Whitney Museum of American Art, New York. Gift of Dr. and Mrs. Abraham Melamed, 74.80*

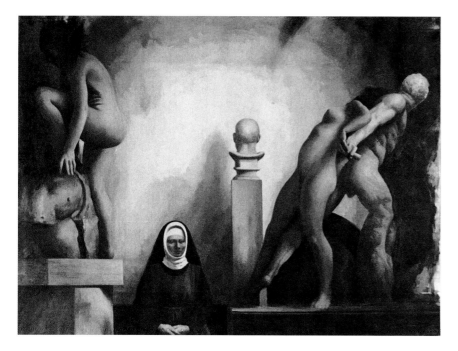

Roman eras. I was always looking at ancient Greek sculptures, Egyptian art, up to the Renaissance, Degas—the great role models.

**MP:** What in particular attracts you about the nude?

**SG:** It's great looking. It's a primal force, I guess, and you can't beat it. It's what you dream about, it's a part of life—it's a major part of life.

**MP:** What are the various ways you've approached the nude?

**SG:** Some of them are life studies. At PCA for a while there was a group of faculty and we used to get together once a week or every couple of weeks and draw from the model. Some of them are just straight studies, and some take on an allegorical or some kind of mythological or symbolic idea. Some of

the nudes are existential. Some are just erotic. I guess the ones on the table (see figs. 28–30), maybe you can define as being more existential, where it's almost like a woman as victim—the painting of the woman on the table that the Academy owns (plate 14).

**MP:** In some of the criticism I read, there are people who talk about your nude females as mutilated.

**SG:** They are not mutilated. This one, *Nude on a Red Table* (plate 14)—the heavier painting is more fully developed on the left. As you move from the left to the right, it dissolves. The image disappears, in a way. I don't consider that mutilated. Her head is not there, but it's not like it's been cut off with an ax or a chain saw or something. It's not gory. I think it's evocative. It's suggestive.

It's something that turns the imagination on, in the viewer, I would hope.

**MP:** So you are dealing with this more in terms of formal—

**SG:** It's formal. There is also a hallucinatory quality about it.

**MP:** There are several different things that are said relating to these images. Some people talk about these images as mutilation, but others liken them to Rodin fragments.

**SG:** Well, I think I may have said that myself. The head is not included on the body in this painting. But when that's done in sculpture, it's more accepted. The arms aren't there on the Venus, or the head is off—it becomes a sculptural fragment.

**MP:** Do you see yourself trying to make any sort of statement about women through these images?

**SG:** No. Although one thing I've noticed in the work is that I think the

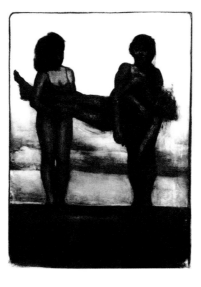

women are often stronger than the men. I think often the men in many of them are more existential; they are either injured or searching or they are seen in more of a negative light than the women. I'm thinking of the drawing of the two women carrying a body of a man (fig. 43). Maybe the women are more heroic in a certain way. But in that painting of the self-portrait—me with the woman on the table (fig. 30)—there it's the reverse. Maybe it's one of the few times where the man is depicted whole and the woman is like an object on a table there— almost like a slab of meat. I think that's maybe one out of ten times where it's like that—generally it's the other way around. I think it was just an imaginative, interesting idea for me to do something like that and to put a twist on it—it's like putting women on a pedestal. It's just like putting a model on a pedestal— here she's on a table. It's not that you start out with some kind of subversive idea. I did it because to me it had some imaginative, dramatic impact. I liked the way it looked visually. Because I put a woman on a table, that doesn't mean I hate women—I think that's silly to think that.

**MP:** *Self-Portrait in Studio* (fig. 30) evoked for me the Eakins painting of the *Gross Clinic,*[6] where they are working on the figure—the leg on the table.

**SG:** That wasn't a conscious thing. I don't see any connection with that. It's an interesting idea, but I think it's a little far removed.

Figure 42. Sidney Goodman. *Room with Light,* 1986. Oil on canvas, 86½ x 117 inches (219.7 x 297.2 cm). *Collection Malcolm Holzman*

Figure 43. Sidney Goodman. *Two Women Carrying a Man,* 1982–84. Charcoal and pastel on paper, 58 x 45¾ inches (147.3 x 116.2 cm). *The Arkansas Arts Center Foundation Collection, Little Rock. The Barrett Hamilton Acquisition Fund, 1985*

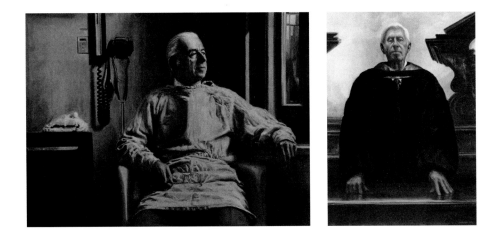

**MP:** What interests you about portraiture? You seem to do a certain amount of it.

**SG:** Yes. I think I always did. I think it was one of the first things that I did even as a child.

**MP:** It seems like you are not doing very many portrait commissions.

**SG:** Well, actually, I just finished a portrait commission. It's of a doctor that happens to live in the neighborhood. The first portrait commission I did was—by mutual awareness or consent—Dr. Robert Pressman, who was an old friend. He was my doctor. And he's been a collector of my work, and I did two portraits of him that are spaced about fifteen years apart. One was in his office with a yellow gown (fig. 44) and one was done about three or four years ago (fig. 45), that's hanging in the College of Physicians in Philadelphia, and he's in black academic robes, because he was the head of the College of Physicians. He was the presiding chairman. He asked

if I was interested in doing a portrait, and in fact, I'd been thinking about it. And I was interested because I happened to like his head. I liked the shape of his head. And then again, around fifteen years later. But I did two portrait commissions in the last two years of people that I didn't know or who were not friends. That's something I didn't think I'd do. I probably wouldn't have done it if I didn't like the way they looked, but there was an interest there and I did them. They knew my work and they knew that what I would do would be not an official-type, conventional portrait, in the same sense that Alice Neel's portraits aren't. And that's where the interest was—they are more personal reactions to somebody. It's like I'm using them as part of the way my imagination works. Almost like a director putting them in a role in a play or something, which is very different than the way Pearlstein would do a portrait. In fact, both our portraits of retired presidents of an insurance company are hanging in

the same building, and this insurance company has a whole gallery of portraits that go back to Ben Franklin, George Washington. Both our portraits are opposite each other, and mine (fig. 46) has a different, dramatic feel—the guy is sitting and it's like he's talking. His mouth is open, and it has a different feel than the Pearlstein, which is more an objective observation. My things are objective, but they are also about some other element.

**MP:** The other portraits that you've done have been members of your family, like the one of your parents, *The Artist's Parents in the Store* (plate 9).

**SG:** I guess that was an homage to my parents and their store, which was so much a part of my life for so many years. I did this just before my father died—this was in the declining years of his life, but also as a store owner. He was getting sick at that time with arteriosclerosis, and I could see that time was running out, and he was always lamenting the fact that the business was gone. Sometimes with me, an experience of doing a painting—the idea of a painting—will be way ahead—years ahead. Sometimes it accumulates, like I'll look at something and a painting won't develop from that until a period of time goes by, where the whole experience—the whole visual experience—gets digested and it gets kind of spit out in the painting. This was kind of the end of something. It's a portrait of both my parents in their world. I've always done portraits of people that are

either myself or the families that I've lived with. My own family, when I was a kid. My parents, and my first marriage. It's an autobiographical thing, as well as portraits. It's part of my experience of life, and whoever is part of my life, in some way winds up in a painting.

**MP:** One of the things that I thought of when I was looking at some of your landscapes is that many of them have—

**SG:** A lot of the landscapes have an environmental feel to them. Before the whole environmental movement, I was always aware how the environment was changing. Just driving through the country for my first trip in '64—and as time went on, with each year with the growing spread, like some kind of a cancer or something—I kept seeing the landscape being tampered with and all of these forms like gas tanks and big radar screens. I guess I was imagining them as ominous or as sinister presences. I probably should mention also—people often ask me about the theme of fire in the work. It started with looking at the fires burning in these conical-shaped incinerators, which, I think, have been replaced by a different form of incinerator. I was in the Bicentennial exhibition put on by the Department of the Interior in Washington. It was at the Corcoran Gallery in 1976. Artists were sent out to all the areas included in the jurisdiction of the Department of the Interior, and I did these two paintings. One was a mine flushing project in

Figure 44. Sidney Goodman. *Dr. Robert Pressman,* 1974. Oil on canvas, 36½ x 51 inches (92.7 x 129.5 cm). *Collection Dr. and Mrs. Robert S. Pressman*

Figure 45. Sidney Goodman. *Dr. Robert Pressman,* 1986–87. Oil on canvas, 56 x 40 inches (142.2 x 101.6 cm). *Mütter Museum, College of Physicians of Philadelphia*

Scranton, Pennsylvania, where they were filling in all of these mine shafts because of the sinking streets (*Project at Scranton,* plate 10). The other one I did was *Incinerator* (plate 11). A lot of people went to exotic places, they went to Hawaii, Puerto Rico—and I went to Scranton to do that painting of the mine flushing project.

**MP:** The first retrospective of your work was organized in 1980 when you were forty-four years old.[7] Did seeing all your works reassembled like that have any sort of impact on you or cause any sort of shift in your thinking?

**SG:** I think maybe around that time I wanted to do things that had a little more movement to them or animation. I wanted to get away from things that had maybe ambiguous or ominous implications. I wanted to take an experience that was more direct and take it somewhere—like *Night Burn* (plate 32) or

*A Waste* (plate 29)—or maybe to do something that had more activity.

**MP:** These are very different from the works that we were discussing as classical, although the shift away from them starts in the later seventies.

**SG:** Yes. It had been moving that way. Richard Porter talked about the dual aspect of my work in terms of the romantic and the classic impulses in my work.[8] And I think maybe from that point on, things started getting to be more of a combination of those two, or maybe more romantic or more active or a fuller kind of an experience.

**MP:** Have you ever thought of working purely abstractly?

**SG:** Well, sometimes as a joke when people say, "What do you think you will be painting if you live into your eighties or nineties or something?" I'd say, "Who knows? Maybe I might go back to becoming an abstract painter." But I don't think so. I feel that even though my work is so very much figurative, maybe the early abstraction that I did as a student or the experience of having undergone that has affected the way I paint figures. So there might be some—there are probably some abstract underpinnings—purely aesthetic way of making forms come alive that I think is embedded in kind of an abstract awareness.

**MP:** I'm intrigued by the fact that although you are interested in developing the formal qualities of the paintings, they still retain the sort of disturbing

quality that they had in the early work. Is there anything you can say about that?

**SG:** I think what you are saying is true. But I'm a painter who is interested in the forms of painting, just like a musician is interested in the forms of music—and then the themes are there. The choices of subject matter or ideas or themes or visions or whatever are just a part of my nature. I think that's the way I always was, so that's a given. How they come about, how they change, that's an illogical thing and sometimes I do things that, as I said before, are happening in my experience at the moment, or sometimes I'll remember something and it will feed into what is happening. So there's always a constant reference from the past and present. And then sometimes I'm doing ideas that I haven't touched on yet. I'm doing a painting now whose idea was in my head six years ago—this is this painting of people falling (plate 46), which is the biggest painting I've done so far. It's taken me this long to get to it. But the idea of it was there long before I painted it— that has happened at various times.

1. The name derives from the title of an exhibition of figurative art held at the Museum of Modern Art in New York in 1959, with a catalogue by Peter Selz. See the discussion below.

2. Goodman was the first student from the Philadelphia College of Art to win a fellowship to attend the Yale Summer School of Music and Art in Norfolk, Connecticut. He recalls that it was the same summer that Eva Hesse and Kim Levin, a longtime writer for the *Village Voice,* attended.

3. Selden Rodman, *The Insiders: Rejection and Rediscovery of Man in the Arts of Our Time* (Baton Rouge, 1960). Rodman describes the "Insider" artist as a humanist, committed to expressing human values or the human condition, in contrast to the "Outsider," who either celebrates chaos or ignores its presence. Part of a chapter was devoted to Goodman's friend Peter Paone.

4. The Museum of Modern Art, New York (May 23–September 4, 1962).

5. "The German Atrocities," *Life,* vol. 18, no. 19 (May 7, 1945), pp. 32–37.

6. Jefferson Medical College, Thomas Jefferson University, Philadelphia.

7. Museum of Art, The Pennsylvania State University, University Park, *Sidney Goodman: Paintings, Drawings, and Graphics, 1959–1979* (July 5–October 12, 1980); catalogue edited and with an essay by Richard Porter.

8. Ibid.

Figure 46. Sidney Goodman. *M. Todd Cooke,* 1988–89. Oil on canvas, 34 x 24 inches (86.4 x 61 cm). *The Mutual Assurance Company Collection, Philadelphia*

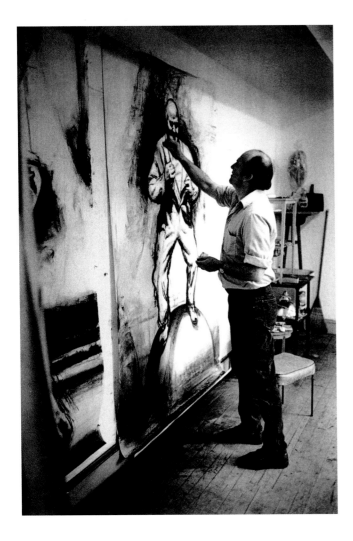

# Biography

*Born*

January 19, 1936, Philadelphia

*Education*

Philadelphia College of Art (now
    University of the Arts), 1954–58

*Teaching*

Philadelphia College of Art, 1960–78
Pennsylvania Academy of the Fine Arts,
    Philadelphia, 1979–present

*Awards and Appointments*

Yale-Norfolk Fellowship, 1957
Philadelphia College of Art, Gimbel Prize
    in Painting, 1958
The Print Club, Philadelphia, Margaret
    Boericke Prize, 1961
Whitney Museum of American Art,
    New York, Neysa McMein Purchase
    Award, 1961
Ford Foundation Purchase, 1962
John Simon Guggenheim Memorial
    Foundation Fellowship, 1964
National Academy of Design, New York,
    First Prize in Painting, 1971
Philadelphia College of Art, The Alumni
    Award, 1971

The Fellowship of the Pennsylvania
    Academy of the Fine Arts, Percy M.
    Owens Memorial for a Distinguished
    Pennsylvania Artist, 1974
National Endowment for the Arts
    Fellowship, 1974
The Butler Institute of American Art,
    Youngstown, Ohio, *39th Annual Midyear
    Show,* First Prize, 1975
University of Houston, Visiting Artist, 1979
Skowhegan School of Painting and
    Sculpture, Skowhegan, Maine, 1985
Southeastern Center for Contemporary
    Art, Winston-Salem, North Carolina,
    Award in the Visual Arts, 1985
Hazlett Memorial Award for Excellence
    in the Arts: Painting, 1986
University of California, Davis,
    Distinguished Visiting Professor, 1987
University of Georgia, Athens, Lamar
    Dodd Professorial Chair, 1991

Figure 47. Sidney Goodman in his studio, 1986

# Exhibition History

Philadelphia Museum of Art. *Pertaining to Philadelphia, Part V: Sidney Goodman.* January 5–June 23, 1985.

Terry Dintenfass Gallery, New York. *Sidney Goodman: Recent Works on Paper.* April 30–June 14, 1985.

Florence Wilcox Gallery, Swarthmore College, Swarthmore, Pennsylvania. *Sidney Goodman: Drawings 1975–1985.* January 29–February 20, 1987. Catalogue.

Terry Dintenfass Gallery, New York. *Sidney Goodman: New Work Part I: Paintings.* March 3–28, 1987. *Sidney Goodman: New Work Part II: Watercolors, Drawings, and Pastels.* April 1–30, 1987. Catalogue. Essay by John Yau.

Terry Dintenfass Gallery, New York. *Sidney Goodman: Recent Drawings and Sculpture.* March 2–30, 1989.

J. Rosenthal Fine Arts, Ltd., Chicago. *Sidney Goodman: Recent Works.* May 5–31, 1989.

Terry Dintenfass Gallery, New York. *Sidney Goodman: Overview, 1969–1989.* April 4–May 2, 1990.

Georgia Museum of Art, The University of Georgia, Athens. *Sidney Goodman: Drawings, Watercolors, and Oils.* February 2–March 10, 1991.

Terry Dintenfass Gallery, New York. *Sidney Goodman: Recent Work.* April 13–May 11, 1991.

Terry Dintenfass Gallery, New York. *Sidney Goodman: Recent Work on Paper.* April 11–May 16, 1992.

Flowers East, London. *Sidney Goodman:*

*Drawings.* July 1–August 1, 1993. Catalogue. Text by Ann Temkin.

Terry Dintenfass Gallery, New York. *Sidney Goodman: Recent Paintings.* December 11, 1993–January 22, 1994.

The More Gallery, Philadelphia. *Sidney Goodman: Drawings.* January 28–March 2, 1994.

Terry Dintenfass Gallery, New York. *Sidney Goodman: Recent Work on Paper.* March 23–April 29, 1995.

Kauffman Gallery, Huber Art Center, Shippensburg University, Shippensburg, Pennsylvania. *Sidney Goodman: Paintings and Other Works on Paper.* April 3–21, 1995.

Museum of American Art of the Pennsylvania Academy of the Fine Arts, Philadelphia. *Artist's Choice: Sidney Goodman.* February 10–April 14, 1996.

## Selected Group Exhibitions

The Print Club, Philadelphia. *Exhibition of Prints by Sidney Goodman, Peter Paone, Helen Shulik.* September 15–October 3, 1958.

Pennsylvania Academy of the Fine Arts and the Philadelphia Water Color Club. *The 154th Annual Exhibition: Water Colors, Prints, and Drawings.* January 25–March 1, 1959. Checklist. Also exhibited in this show in 1961, 1965, 1967, and 1969 (checklists).

Philadelphia Museum of Art. *Second Philadelphia Arts Festival Regional*

*Exhibition.* January 31–March 8, 1959. Catalogue. Essays by Henri Marceau et al. Also exhibited in this show in 1962.

The Print Club, Philadelphia. *The 34th Annual Exhibition of Wood Engraving, Woodcuts, and Block Prints.* February 5–26, 1960.

Cheltenham Art Center, Cheltenham, Pennsylvania. *13th Annual Award Exhibition.* April 1961.

Saint Paul Gallery and School of Art (now Minnesota Museum of American Art). *Drawings USA 1961.* November 16–December 22, 1961. Catalogue. Also exhibited in this show in 1968 (catalogue; traveled), 1971 (catalogue), and 1975 (catalogue; traveled).

Terry Dintenfass Gallery, New York. *Evergood, Frasconi, Goodman, Gwathmey, Katzman.* November 20–December 9, 1961.

The Museum of Modern Art, New York. *Recent Painting USA: The Figure.* May 23–September 4, 1962. Traveled. Catalogue. Essay by Alfred H. Barr, Jr.

Whitney Museum of American Art, New York. *Forty Artists Under Forty from the Collection of the Whitney Museum of American Art.* July 23–September 16, 1962. Traveled. Catalogue.

Whitney Museum of American Art, New York. *Annual Exhibition 1962: Contemporary Sculpture and Drawings.* December 12, 1962–February 3, 1963. Checklist.

The Corcoran Gallery of Art,

Washington, D.C. *28th Biennial Exhibition of Contemporary American Painting.* January 18–March 3, 1963. Checklist.

The Brooklyn Museum. *22nd International Watercolor Biennial: Yugoslavia, Sweden, United States.* February 19–April 28, 1963. Catalogue.

American Academy of Arts and Letters, New York. *Painting and Sculpture by Candidates for Art Awards.* March 8–24, 1963. Also exhibited in this show in 1970, 1973, 1974, 1984, and 1985.

The Museum of Modern Art, New York. *Sixty Modern Drawings: Recent Acquisitions.* August 6–September 29, 1963.

Whitney Museum of American Art, New York. *Annual Exhibition 1963: Contemporary American Painting.* December 11, 1963–February 2, 1964. Catalogue. Also exhibited in this show in 1967–68 and 1969–70 (checklists).

The Print Club, Philadelphia. *Black and White Exhibition.* February 7–28, 1964. Also exhibited in this show in 1965, 1967, and 1968 (traveled, 1968).

Whitney Museum of American Art, New York. *The Friends Collect: Recent Acquisitions by Members of the Friends of the Whitney Museum of American Art.* May 8–June 16, 1964. Catalogue.

Pennsylvania Academy of the Fine Arts, Philadelphia. *Regional Exhibition: Paintings, Sculpture, Prints, and Drawings by Artists of Philadelphia and Vicinity.* October 9–November 15, 1964. Checklist.

Philadelphia Art Alliance. *Four Figure Painters.* January 11–February 7, 1965.

American Academy of Arts and Letters, New York. *Hassam Fund Purchase Exhibition.* February 5–21, 1965. Also exhibited in this show in 1966, 1970, and 1971, and in the *Hassam and Speicher Fund Purchase Exhibition,* 1978 and 1979.

Whitney Museum of American Art, New York. *A Decade of American Drawings: 1955–1965.* April 28–June 6, 1965. Catalogue.

Whitney Museum of American Art, New York. *Young America 1965: Thirty American Artists Under Thirty-Five.* June 23–August 29, 1965. Catalogue.

Weatherspoon Art Gallery, The University of North Carolina at Greensboro. *Art on Paper 1965.* November 1–24, 1965. Catalogue.

Cheltenham Art Center, Cheltenham, Pennsylvania. *New Talent.* 1967.

Herron Museum of Art, Indianapolis. *Painting and Sculpture Today—'67.* January 8–February 12, 1967. Checklist.

Allan Frumkin Gallery, New York. *The Nude Now.* January 10–February 4, 1967.

Philadelphia Museum of Art. *Stampe di due mondi: Prints of Two Worlds.* May 15–June 25, 1967. Traveled internationally. Catalogue. Essays by Maurizio Calvesi et al.

The Museum of Modern Art, New York. *Drawings: Recent Acquisitions.* June 26–November 22, 1967.

The Philadelphia Art Alliance. *Self-Portraits by Philadelphia Artists.* October 2–29, 1967.

Wollman Hall, New School Art Center, New York. *Protest and Hope: An Exhibition of Contemporary American Art.* October 24–December 2, 1967. Catalogue.

Vassar College Art Gallery, Poughkeepsie, New York. *Realism Now.* May 8–June 12, 1968. Catalogue. Essay by Linda Nochlin.

Wollman Hall, New School Art Center, New York. *The Humanist Tradition in Contemporary American Painting.* October 15–November 23, 1968. Catalogue.

The Brooklyn Museum. *16th National Print Exhibition: Two Decades of American Prints, 1947–1968.* October 29, 1968–January 26, 1969. Catalogue.

Philadelphia Museum of Art. *Recent Acquisitions: Prints and Drawings Department.* November 15–December 22, 1968.

Krannert Art Museum, College of Fine and Applied Arts, University of Illinois Urbana-Champaign, Champaign. *Contemporary American Painting and Sculpture 1969.* March 2–April 6, 1969. Catalogue. Essay by James R. Shipley and Allen S. Weller.

Philbrook Art Center, Tulsa, Oklahoma. *The American Sense of Reality.* March 4–25, 1969. Traveled. Catalogue.

The Brooklyn Museum. *Listening to Pictures.* Opened April 28, 1969 (long-term installation). Catalogue.

Whitney Museum of American Art, New York. *Human Concern/Personal Torment: The Grotesque in American Art.* October 14–November 30, 1969. Traveled. Catalogue. Text by Robert Doty.

Göteborgs Konsthallen, Gothenburg, Sweden. *Warmwind: Amerikanska Realister.* March 26–April 12, 1970. Traveled. Catalogue. Essay by Anders Bergh.

Philadelphia Museum of Art. *Peace.* May 19–June 21, 1970.

State University of New York College at Potsdam. *New Realism.* 1971.

Van Deusen Galleries, Kent State University School of Art, Kent, Ohio. *Fifth Annual Invitational Exhibition (Drawing, Prints, Multiples).* April 4–25, 1971. Checklist. Essay by John Perreault.

The Suffolk Museum, Stony Brook, New York. *The Contemporary Figure—A New Realism.* August 14–October 7, 1971. Catalogue. Organized by June Blum.

Lowe Art Museum, University of Miami, Coral Gables, Florida. *Phases of New Realism.* January 20–February 20, 1972. Checklist.

Boston University Art Gallery. *The American Landscape/1972.* January 21–February 19, 1972. Catalogue.

Cleveland Institute of Art. *Twenty-Two Contemporary Realists.* October–November 1972.

Joslyn Art Museum, Omaha, Nebraska. *A Sense of Place: The Artist and the American Land.* September 23–October 28, 1973. Traveled. Book (volume 1) and catalogue (volume 2). Text by Alan Gussow.

Museum of the Philadelphia Civic Center and the Fellowship of the Pennsylvania Academy of the Fine Arts. *Annual Fellowship Exhibition.* March 2–31, 1974. Catalogue.

Virginia Museum of Fine Arts, Richmond. *Works on Paper.* September 30–November 10, 1974. Catalogue. Essay by Frederick R. Brandt.

Westminster College, New Wilmington, Pennsylvania. *The Figure in Recent American Painting.* October 1–November 5, 1974. Traveled. Catalogue. Text by Robert Godfrey et al.

Museum of Art, The Pennsylvania State University, University Park. *Living American Artists and the Figure.* November 3–December 22, 1974. Catalogue. Essay by William D. Davis.

The William Benton Museum of Art, The University of Connecticut, Storrs. *Drawings: Techniques and Types.* February 8–March 9, 1975. Catalogue. Text by Frederick den Broeder and Stephanie Terenzio.

The Schick Art Gallery, Skidmore College, Saratoga Springs, New York. *Twentieth-Century Drawings.* February 28–March 17, 1975.

The Butler Institute of American Art, Youngstown, Ohio. *39th Annual Midyear Show.* June 29–August 31, 1975. Catalogue. Also exhibited in this show in 1976 (catalogue), 1980 (checklist), 1981 (checklist), 1982 (catalogue), 1983 (catalogue), 1986 (catalogue), and 1988 (catalogue).

De Cordova Museum, Lincoln, Massachusetts. *candid painting: American Genre, 1950–1975.* October 12–December 7, 1975. Catalogue. Essay by Eva Jacob.

The Queens Museum, Flushing, New York. *Urban Aesthetics.* January 17–February 29, 1976. Catalogue. Essay by Janet Schneider.

Alumni Memorial Gallery, Lehigh University, Bethlehem, Pennsylvania. *American Figure Drawing.* February 15–March 9, 1976. Traveled internationally. Catalogue. Essay by W. J. Kelly.

Brainerd Hall Art Gallery, The State University College at Potsdam, Potsdam, New York. *The Presence and the Absence in Realism.* March 26–April 30, 1976. Catalogue.

Philadelphia Museum of Art. *Philadelphia: Three Centuries of American Art.* April 11–October 10, 1976. Catalogue.

Corcoran Gallery of Art, Washington, D.C. *America 1976: A Bicentennial Exhibition Sponsored by the United States Department of the Interior.* April 27–June 6, 1976. Traveled. Catalogue. Essays and poems by Robert R. Rosenblum et al.

Squibb Gallery, Princeton, New Jersey. *Contemporary Art of Philadelphia.* January 16–February 13, 1977. Catalogue.

Philadelphia Museum of Art. *Gifts to Mark a Century: An Exhibition Celebrating the Centennial of the Philadelphia Museum of Art.* February 18–March 20, 1977. Catalogue.

National Academy of Design, New York. *152nd Annual Exhibition.* February 26–March 20, 1977. Catalogue. Also exhibited in this show in 1979 and 1982 (catalogues).

Philadelphia Museum of Art. *Recent Acquisitions: Made in Philadelphia.* March 18–September 1, 1977.

The Dimock Gallery, The George Washington University, Washington, D.C. *Tenth Anniversary Exhibition: Area Invitational Painting Show.* May 18–June 17, 1977.

Pennsylvania Academy of the Fine Arts, Philadelphia. *Eight Contemporary American Realists.* September 16–October 30, 1977. Traveled. Catalogue. Text by Frank H. Goodyear, Jr.

Fine Arts Gallery of San Diego. *Invitational American Drawing Exhibition.* September 17–October 30, 1977. Checklist.

Fondation Nationale pour les Arts Graphiques et Plastiques, Paris. *Papiers sur nature: Festivale d'Automne à Paris.* October 14–November 27, 1977. Catalogue. Text by Jean Clair and Dominique Pallut.

Weatherspoon Art Gallery, University of North Carolina at Greensboro. *Art on Paper 1977.* November 13–December 18, 1977. Catalogue.

The Schick Art Gallery, Skidmore College, Saratoga Springs, New York. *Surrealistic Formalism.* February 3–19, 1978.

Whitney Museum of American Art, New York. *Twentieth-Century American Drawings: Five Years of Acquisitions.* July 28–October 1, 1978. Catalogue. Text by Paul Cummings.

Sheldon Memorial Art Gallery, University of Nebraska, Lincoln. *Things Seen.* September 5–October 1, 1978. Traveled. Catalogue. Essay by Norman A. Geske.

Pennsylvania Academy of the Fine Arts, Philadelphia. *Artist and Teacher: An Exhibition by the Faculty of the Pennsylvania Academy of the Fine Arts.* March 8–April 28, 1979. Catalogue.

Ralph Wilson Gallery, Lehigh University, Bethlehem, Pennsylvania. *24th Annual Contemporary American Painting: The Revival of Realism.* March 9–April 19, 1979. Catalogue. Essay by Lucille Bunin Askin.

Philadelphia Museum of Art. *Contemporary Drawings: Philadelphia II.* March 24–May 20, 1979. Catalogue. Essay by Ann Percy.

Minnesota Museum of Art/Community Gallery, Saint Paul. *West '79/The Law.* March 29–May 11, 1979. Traveled. Catalogue. Also exhibited in this show in 1990 (traveled; catalogue).

Artists' Choice Museum, New York. *Artists Choose: Figurative/Realist Art.* September 8–22, 1979. Catalogue. Essays by Robert Godfrey and Howard Kalish.

Mitchell Museum, Mount Vernon, Illinois. *American Watercolorists 1979.* November 3–December 31, 1979. Traveled. Catalogue.

National Portrait Gallery, Washington, D.C. *American Portrait Drawings.* May 1–August 3, 1980. Catalogue. Text by Marvin Sadik and Harold Francis Pfister.

Whitney Museum of American Art, New York. *The Figurative Tradition and the Whitney Museum of American Art: Paintings and Sculpture from the Permanent Collection.* June 25–September 28, 1980. Catalogue. Text by Patricia Hills and Roberta K. Tarbell.

Minnesota Museum of Art, Saint Paul. *Drawings in Saint Paul: Selections from The Miriam B. and Malcolm E. Lein Collection.* October 16–December 23, 1980. Catalogue.

The Arkansas Arts Center, Little Rock. *The Collector's Show.* December 3–30, 1980. Also exhibited in this show in 1981–82, 1986–87, 1987–88, 1988–89, 1989–90, 1991–92, and 1992.

Gibbes Art Gallery, Charleston, South Carolina. *Ten Pens: An Exhibition of Ball Point Pen Drawings.* July 1–August 9, 1981. Traveled. Catalogue. Essay by Jeff Kipnis.

Sordoni Art Gallery, Wilkes College, Wilkes-Barre, Pennsylvania. *A Range of Contemporary Drawing.* August 31–September 20, 1981. Checklist.

Pennsylvania Academy of the Fine Arts, Philadelphia. *Contemporary American Realism Since 1960.* September 18–December 13, 1981. Traveled internationally. Catalogue. Text by Frank H. Goodyear, Jr.

Marquette University, Milwaukee, Wisconsin. *Changes: Art in America 1881/1981.* October 5–November 6, 1981. Catalogue. Essays by Curtis L. Carter and Dennis Adrian.

Terry Dintenfass Gallery and Grace Borgenicht Gallery, New York. *20/20: Twenty Galleries, Twenty Years.* January 9–February 4, 1982. Catalogue.

Mary Ryan Gallery, New York. *Recent Prints and Drawings by Sigmund Abeles, David Brumback, Sidney Goodman, Peter Milton.* March 30–April 25, 1982.

Root Art Center, Hamilton College, Clinton, New York. *Drawings, Watercolors, and Prints by Contemporary Masters.* April 15–May 28, 1982. Checklist.

The More Gallery, Philadelphia. *Portraits.* July 12–August 1, 1982.

Rose Art Museum, Brandeis University, Waltham, Massachusetts. *Herbert W. Plimpton Collection of Realist Art.* September 12–October 24, 1982.

Tyler School of Art, Temple University, Philadelphia. *The Renaissance Revisited.* October 7–November 7, 1982.

Pratt Manhattan Center, New York. *Artist's Protest.* October 16–November 6, 1982.

Howard A. Wolf Gallery and Edith Rosenwald Gallery, Philadelphia College of Art. *Affects/Effects: Past Faculty of Philadelphia College of Art.* November 19–December 21, 1982. Catalogue. Essay by Elaine J. Cocordas.

Pennsylvania Academy of the Fine Arts, Philadelphia. *Perspectives on Contemporary*

*American Realism: Works of Art on Paper from the Collection of Jalane and Richard Davidson.* December 17, 1982–February 20, 1983.

The More Gallery, Philadelphia. *Allegorical and Narrative Painting and Sculpture.* February 4–28, 1983.

Center Gallery, Bucknell University, Lewisburg, Pennsylvania. *Faces Since the 50's: A Generation of American Portraiture.* March 11–April 17, 1983. Catalogue. Essay by Joseph Jacobs.

Southern Alleghenies Museum of Art, Loretto, Pennsylvania. *Painters of the Pennsylvania Landscape.* September 24–November 27, 1983. Catalogue. Essay by Michael M. Strueber.

Museum of Fine Arts, Boston. *Brave New Works: Recent American Painting and Drawing.* November 10, 1983–January 29, 1984.

Robert and Jane Meyerhoff Gallery, Maryland Institute, College of Art, Baltimore. *Drawings by Contemporary American Figurative Artists.* September 28–November 24, 1984. Checklist.

International Exhibitions Foundation, Washington, D.C. *Twentieth-Century American Drawings: The Figure in Context.* 1984–85. Traveled. Catalogue. Text by Paul Cummings.

Artists' Choice Museum, New York. *Artists Choosing Artists.* May 28–July 21, 1985.

Museum of Art, Colby College, Waterville, Maine. *The Skowhegan School of Painting and Sculpture 1985 Exhibition.* July 3–August 25, 1985.

Southeastern Center for Contemporary Art, Winston-Salem, North Carolina. *Awards in the Visual Arts 4.* August 2–September 29, 1985. Traveled. Catalogue. Essay by Peter Frank.

San Francisco Museum of Modern Art. *American Realism: Twentieth-Century Drawings and Watercolors from the Glenn C. Janss Collection.* November 7, 1985–January 12, 1986. Traveled. Catalogue. Text by Alvin Martin.

Wichita Art Museum, Wichita, Kansas. *A Decade of American Realism: 1975–1985.* December 7, 1985–January 5, 1986. Catalogue. Text by Howard DaLee Spencer.

Payne Gallery, Moravian College, Bethlehem, Pennsylvania. *Intimate and Intense: New Genre Painting.* January–May 1986.

Philadelphia Museum of Art. *Pertaining to Philadelphia, Part VI: Works on Paper from the Seventies and Eighties.* March 8–May 6, 1986.

Southern Alleghenies Museum of Art, Loretto, Pennsylvania. *The 1986 Hazlett Memorial Awards Exhibition for the Visual Arts.* May 17–June 15, 1986. Traveled. Catalogue. Essay by Michael Allison.

The Arkansas Arts Center, Little Rock. *National Drawing Invitational.* May 17–June 29, 1986.

Philadelphia Museum of Art. *Philadelphia Collects: Art Since 1940.* September 28–November 30, 1986. Catalogue. Organized by Mark Rosenthal with Ann Percy.

Greenville County Museum of Art, Greenville, South Carolina. *Here and Now.* October 28, 1986–January 4, 1987.

Huntsville Museum of Art, Huntsville, Alabama. *Drawing: The New Tradition.* January 18–March 8, 1987.

New York State Museum, Albany. *Diamonds Are Forever: Artists and Writers on Baseball.* September 16–November 15, 1987. Traveled internationally. Catalogue. Edited by Peter H. Gordon with Sydney Waller and Paul Weinman.

The Heckscher Museum, Huntington, New York. *The Artist's Mother: Portraits and Homages.* November 14, 1987–January 3, 1988. Traveled. Catalogue. Organized by Barbara Coller. Essays by John E. Gedo and Donald Kuspit.

National Academy of Design, New York. *Realism Today: American Drawings from the Rita Rich Collection.* December 11, 1987–February 22, 1988. Traveled. Catalogue.

Anchorage Museum of History and Art, Anchorage, Alaska. *Portraits: Here's Looking at You.* June 19, 1988–June 1, 1989. Catalogue.

Silvermine Gallery/Metro Center, New Canaan, Connecticut. *The Figure in American Art Since Mid-Century: Avery to Warhol.* June 28–July 30, 1988.

Nexus Gallery, Philadelphia. *The Family in Contemporary Art.* January 4–27, 1989.

Center Gallery, Bucknell University, Lewisburg, Pennsylvania. *Reagan: American Icon.* January 14–March 23,

1989. Traveled. Catalogue. Text by Robert P. Metzger.

The Arkansas Arts Center, Little Rock. *Revelations Drawing/America.* January 19–March 26, 1989. Traveled internationally. Catalogue. Text by Townsend Wolfe et al.

Sherry French Gallery, New York. *Love and Charity: The Tradition of "Caritas" in Contemporary Painting.* February 1–25, 1989. Traveled.

Mead Art Museum, Amherst College, Amherst, Massachusetts. *An American Collector: Herbert W. Plimpton.* March 8–April 24, 1989.

Procter Art Center, Bard College, Annandale-on-Hudson, New York. *Mystery.* March 18–April 12, 1989. Traveled.

Philadelphia Museum of Art. *Twenty-Five Years of Gifts from the Friends of the Philadelphia Museum of Art: Prints, Drawings, and Photographs.* March 18–May 21, 1989.

Carnegie Mellon Art Gallery, Pittsburgh. *Perspectives from Pennsylvania: Drawing.* September 9–October 22, 1989. Checklist.

Phyllis Kind Gallery, New York. *"Human Concern/Personal Torment: The Grotesque in American Art" Revisited.* October 14–November 8, 1989. Traveled. Catalogue. Essay by Robert Doty.

The Arkansas Arts Center, Little Rock. *The Figure.* November 16, 1989–February 11, 1990.

Maier Museum of Art, Randolph-Macon Woman's College, Lynchburg, Virginia. *Realism in a Post-Modern World: Selections from the Sydney and Frances Lewis Collection.* January 21–March 25, 1990. Checklist.

Philadelphia Museum of Art. *Figure Drawings from the Collection.* January 27–April 15, 1990.

The Pennsylvania Academy of the Fine Arts School, Philadelphia. *Faculty: Then and Now.* September 21–October 20, 1990.

Krasdale Foods Art Gallery, in cooperation with Lehman College Art Gallery, Bronx, New York. *Humor, Satire, and Irony: Definitions and Discoveries.* October 19–December 18, 1990.

Weatherspoon Art Gallery, University of North Carolina at Greensboro. *The 26th Annual Exhibition of Art on Paper.* November 18, 1990–January 6, 1991. Catalogue.

Institute of Contemporary Art, Philadelphia. *Philadelphia Art Now: Artists Choose Artists.* January 19–March 3, 1991. Catalogue. Organized by Julie Courtney with Janet A. Kaplan and Judith E. Tannenbaum.

Foster Gallery, University of Wisconsin–Eau Claire. *Drawing on Tradition.* January 24–February 14, 1991.

Southern Alleghenies Museum of Art, Loretto, Pennsylvania. *Against the Grain: Images in American Art, 1960–1990.* June 9–September 9, 1991. Catalogue.

Midtown Payson Galleries, New York. *I, Myself, and Me: Twentieth-Century and Contemporary Self-Portraits.* January 9–February 1, 1992.

Atrium Gallery, School of Fine Arts, University of Connecticut, Storrs. *Figures: Drawings by Sigmund Abeles, Sidney Goodman, and Jody Mussoff.* January 20–February 7, 1992.

American Academy and Institute of Arts and Letters, New York. *Academy-Institute Invitational Exhibition of Painting and Sculpture.* March 3–29, 1992.

The Museum of Fine Arts, Houston. *Singular and Plural: Recent Accessions, Drawings and Prints, 1945–91.* August 1992.

Yale University Art Gallery, New Haven. *Prints, Drawings, Photographs, and Watercolors: Three Years of Acquisitions.* January 5–March 7, 1993.

Sewall Art Gallery, Rice University, Houston. *Contemporary Realist Watercolor.* February 25–April 10, 1993. Brochure.

Tower Fine Arts Gallery, SUNY College at Brockport. *New Approaches to the Still Life.* March 2–April 3, 1993.

Edna Carlsten Gallery, University of Wisconsin–Stevens Point. *Drawing on the Figure.* March 28–April 25, 1993. Catalogue.

Art Institute of Chicago. *Recent Acquisitions: Twentieth-Century Works on Paper in the Permanent Collection.* July 16, 1993–January 23, 1994.

Woodmere Art Museum, Philadelphia. *Figural Philadelphia.* October–November 13, 1993.

Kitakyushu Municipal Museum of Art, Kitakyushu, Japan. *New York Realism—Past and Present.* August 13–September 25, 1994. Traveled. Catalogue.

Drasdale Gallery, White Plains, New York. *The Art of Justice.* April 24–July 21, 1995.

Suzanne H. Arnold Art Gallery, Lebanon Valley College, Annville, Pennsylvania. *The Spiritual Dimension.* June 8–July 13, 1995.

Aspen Art Museum, Aspen, Colorado. *Contemporary Drawing: Exploring the Territory.* July 27–September 24, 1995. Catalogue. Essay by Mark Rosenthal.

# Selected Bibliography

Amichai, Yehuda. "Poems from *Songs of Jerusalem & Myself*." *The American Poetry Review,* special supplement (March–April 1973), pp. 26–32.

Apesos, Anthony. "Reaffirming Western Values Through the Depiction of Space." *New Art Examiner,* vol. 8, no. 4 (January 1981), pp. 4–5.

Arthur, John. "Sidney Goodman." *Art New England,* vol. 3, no. 6 (May 1982), p. 9.

"Art Museum Spotlights Philadelphians." *The Philadelphia Tribune,* January 18, 1985, Arts section, p. 6.

"Art: They Paint; You Recognize." *Time,* vol. 83, no. 14 (April 3, 1964), pp. 74–76.

Barboza, Steven. "A Mural Program to Turn Graffiti Offenders Around." *Smithsonian,* vol. 24, no. 4 (July 1993), pp. 62–71.

Bassett, Barbara. "Family Ties and Tensions: Sidney Goodman." *School Arts,* vol. 94, no. 6 (February 1995), pp. 33–36.

Beans, Bruce. "Sidney Goodman: Still 'Finding a Way' to Paint." *The Columns: A Quarterly Publication of Philadelphia College of the Arts,* vol. 2, no. 1 (1986), p. 12.

Beck, James H. "Sidney Goodman," in "Reviews and Previews: New Names This Month." *Art News,* vol. 60, no. 9 (January 1962), p. 17.

Bell, Jane. "Sidney Goodman at Terry Dintenfass." *Arts Magazine,* vol. 49, no. 7 (March 1975), p. 26.

Bertugli, David, and Jane Biberman.

"Portrait of the Artists." *Inside Magazine,* vol. 10, no. 4 (Winter 1989), pp. 99–106, 152–53.

Brandt, Frederick R., and Susan L. Butler. *Late Twentieth-Century Art from the Sydney and Frances Lewis Foundation.* Richmond, 1981.

Brenson, Michael. "Sidney Goodman: 'The Elements—Archangel,'" in "Art: Howard Hodgkin and Paris Legacy." *The New York Times,* April 27, 1984, sec. C, p. 23.

———. "Artists Choosing Artists," in "Art: 'Painterly Visions' of Guggenheim." *The New York Times,* July 5, 1985, sec. C, p. 16.

Calos, Katherine. "Artist's Dreams Bring Mystery, Realism." *The Richmond News Leader,* December 16, 1981, p. 22.

Canaday, John. "Forty Americans: The Whitney Selects a Good Show and Starts It on a State Tour." *The New York Times,* July 29, 1962, sec. 2, p. 9.

———. "Whitney Again: The Annual Shows Regulars Along with Twenty-Two Newcomers." *The New York Times,* December 17, 1962, sec. 2, p. 21.

———. "Art: Starting from the Top—Sidney Goodman's Show." *The New York Times,* October 16, 1965, sec. 1, p. 23.

———. "Art: The Whitney Museum Annual." *The New York Times,* December 13, 1967, sec. 1, p. 54.

———. "Throw Away That Incubator." *The New York Times,* November 10, 1968, sec. D, p. 31.

———. "Art: The American Realism of

Sidney Goodman." *The New York Times,* December 5, 1970, sec. C, p. 26.

———. "Sidney Goodman," in "Art: Okada's Work Is Pleasure to See." *The New York Times,* March 24, 1973, p. 29.

Clafin, Edward. "Art: The Weather Vane." *Time,* vol. 83, no. 1 (January 3, 1964), pp. 62–66.

———. "Sidney Goodman: The Return to What Reality?" *Intellectual Digest,* vol. 3, no. 10 (June 1973), pp. 40–41.

Cohen, Ronny. "Sidney Goodman," in "New York Reviews." *Art News,* vol. 83, no. 7 (September 1984), p. 147.

Cooper, James. "Goodman Exhibit Fuses Several Intense Styles." *New York City Tribune,* March 20, 1987.

Cope, Penelope Bass. "Sidney Goodman: An Impressive View of the Bizarre." *Wilmington Sunday News Journal* (Delaware), May 17, 1981, sec. F, p. 4.

Dekom, Otto. "Goodman's Art Probes Human Character." *Wilmington Morning News* (Delaware), May 13, 1981, sec. D, p. 6.

Donohoe, Victoria. "Philadelphia Painters Win Accolades in New York." *The Philadelphia Inquirer,* August 28, 1966, Art News section, p. 6.

———. "Peale House Menu of Substantial Fare." *The Philadelphia Inquirer,* December 22, 1968, Art News section, p. 6.

———. "Goodman, Saunders Solos Offer Some Choice Viewing." *The Philadelphia Inquirer,* January 31, 1975, sec. C, p. 3.

———. "Academy Hosts Realist Exhibit." *The Philadelphia Inquirer,* September 18, 1977, sec. G, pp. 1, 13.

———. "Law Theme Carries Strong Message at Exhibit." *The Philadelphia Inquirer,* April 13, 1980, sec. H, p. 9.

———. "Showcase of a Philadelphia Artist's Courage and Range." *The Philadelphia Inquirer,* May 17, 1981, sec. L, p. 15.

———. "The Soul of 'New Talent' Show Is Academic, Its Thrust Avant-Garde." *The Philadelphia Inquirer,* July 23, 1982, sec. E, p. 38.

———. "A View of History Offering Fantasy or Authenticity." *The Philadelphia Inquirer,* January 30, 1983, sec. H, p. 15.

———. "An Original Deserving of More Notice." *The Philadelphia Inquirer,* October 9, 1983, sec. G, p. 23.

———. "Cumulative Effect of Goodman Show Is a Powerful One." *The Philadelphia Inquirer,* January 19, 1985, sec. D, p. 3.

———. "Deep Meanings Beneath His Glitzy Surfaces." *The Philadelphia Inquirer,* February 6, 1987, Weekend section, p. 38.

Duffy, Glen. "Sidney Goodman's Brush with Greatness." *Philadelphia Magazine,* vol. 85, no. 7 (July 1994), pp. 52–57, 92, 94.

Edelman, Robert G. "Sidney Goodman at Terry Dintenfass," in "Review of Exhibitions." *Art in America,* vol. 75, no. 11 (November 1987), pp. 184–85.

Faunce, Sarah C. "Sidney Goodman," in "Reviews and Previews." *Art News,* vol. 62, no. 1 (March 1963), p. 50.

Frank, Peter. "Known Qualities." *Village Voice,* December 11, 1978, p. 105.

———. "Sidney Goodman: Paintings, Drawings, and Graphics, 1959–1979." *Art Express,* vol. 1, no. 2 (September–October 1981), pp. 57–58.

Glueck, Grace. "Sidney Goodman," in "Art: A Nostalgic Look to 'The Surreal City.'" *The New York Times,* May 31, 1985, sec. C, p. 20.

Goldstein, Nathan. *The Art of Responsive Drawing.* 2nd ed. Englewood Cliffs, N.J., 1977.

Grafly, Dorothy. "Print Club Trio," in "The Art World." *The Philadelphia Sunday Bulletin,* September 21, 1958, sec. 5, p. 12.

———. "Color Predominates in Print Club Exhibition," in "The Art World." *The Philadelphia Sunday Bulletin,* February 7, 1960, sec. WB, p. 11.

———. "Germantown Exhibit Keyed to Variation in Responses." *The Philadelphia Sunday Bulletin,* May 16, 1965, sec. 2, p. 3.

Gruen, John. "The Macabre Bathed in Pearly Light." *New York Herald-Tribune,* April 5, 1964, Magazine section, p. 34.

———. "Marisol, Johnson, Ito, Goodman, Denby." *The Soho Weekly News,* March 20, 1975, p. 16.

Hays, Sandy Miller. "Visiting Artist Offers Awards, Advice." *Little Rock Arkansas Democrat,* October 7, 1981, sec. F, p. 6.

Henry, Gerrit. "Sidney Goodman at Terry Dintenfass," in "Review of Exhibitions." *Art in America,* vol. 72, no. 8 (September 1984), p. 216.

———. "Sidney Goodman at Terry Dintenfass," in "New York Reviews." *Art News,* vol. 86, no. 6 (Summer 1987), pp. 205–6.

———. "Sidney Goodman, Terry Dintenfass," in "Reviews." *Art News,* vol. 90, no. 7 (September 1991), p. 126.

———. "Sidney Goodman at Dintenfass." *Art in America,* vol. 80, no. 11 (November 1992), p. 135.

Judd, Donald. "Sidney Goodman," in "New York Exhibitions: In the Galleries." *Arts Magazine,* vol. 38, nos. 8–9 (May–June 1964), p. 40.

Karmel, Pepe. "Sidney Goodman at the Queens Museum," in "Review of Exhibitions." *Art in America,* vol. 69, no. 2 (February 1981), p. 154.

Katz, Jonathan G. "What You See Is Not All There." *The Philadelphia Bulletin,* May 24, 1981, sec. G, p. 6.

Kaufman, Charles. "Goodman Uses Brush to Hit with Power." *Little Rock Arkansas Gazette,* October 16, 1981, sec. B, p. 6.

Kelly, W. J. "Two Who Responded." *Art and Artists,* vol. 9 (January 1975), pp. 24–27.

Knipfel, Jim. "At the Edge of Neo-Surrealism." *Welcomat,* vol. 18, no. 2 (August 3, 1988), p. 61.

"Like Half-Forgotten Dreams." *Time,* vol. 81, no. 10 (March 8, 1963), p. 75.

Merritt, Robert. "Goodman Focus of Museum Show." *Richmond Times-Dispatch,* December 13, 1981, sec. L, p. 4.

———. "Sidney Goodman." *Richmond Times-Dispatch,* December 17, 1981, sec. F, p. 12.

"New ICA Show Features Art of 'Anxious Realism.'" *The Richmond News Leader,* December 5, 1981, sec. A, p. 30.

Nordstrom, Sherry Chayat. "Visiting Artist Likes to Revise 'Finished' Paintings." *Syracuse Post-Standard,* March 1, 1979, p. 15.

O'Doherty, Brian. "Art: Sidney Goodman—Drawings and Oils at Dintenfass Gallery." *The New York Times,* December 23, 1961, sec. 1, p. 21.

Pacini, Marina. Interview with Sidney Goodman. 1990. Archives of American Art, Smithsonian Institution, Washington, D.C.

Paris, Jeanne. "Color Creates a Mood." *Newsday,* November 14, 1980, sec. 2, p. 19.

Pate, Nancy. "Goodman, the Picture of Ambiguity." *The Wichita Eagle-Beacon,* October 21, 1984, sec. F, pp. 1, 2.

Percy, Ann B. "*Man Against a Wall,* 1979–80, Sidney Goodman." *Philadelphia Museum of Art Bulletin,* vol. 80, nos. 343–44 (Summer–Fall 1984), pp. 37–39.

Pincus-Witten, Robert. "Sidney Goodman," in "New York." *Artforum,* vol. 9, no. 6 (February 1971), p. 77.

Preston, Malcolm. "Art: Figures in a

Strange Light." *Newsday,* September 24, 1971, sec. 2, p. 9A.

————. "The Realist Works of Sidney Goodman." *Newsday,* November 29, 1980, sec. 2, p. 28.

Preston, Stuart. "Variety Fare: Tworkov Summing-up at Whitney—New Directions Elsewhere." *The New York Times,* March 29, 1964, sec. 10, p. 19.

Proctor, Roy. "The Vision of Sidney Goodman." *The Richmond News Leader,* December 26, 1981, sec. A, p. 40.

Quinn, Jim. "Unconventional: The New Convention Center Has the Best Collection of Local Artwork in the City." *Philadelphia Magazine,* vol. 85, no. 1 (January 1994), pp. 72–74, 159–60.

Raynor, Vivien. "Art: Viewing with 'Naïve' Eyes." *The New York Times,* December 1, 1978, sec. C, p. 18.

————. "Art: Paintings at French Gallery Reflect City Life." *The New York Times,* March 31, 1985, sec. 1, p. 52.

————. "Sidney Goodman." *The New York Times,* March 27, 1987, sec. C, p. 25.

"The Reappearing Figure." *Time,* vol. 79, no. 21 (May 25, 1962), pp. 62–67.

Rice, Robin. "The Art of the Pennsylvania Convention Center." *Philadelphia City Paper,* no. 463 (July 9–16, 1993), p. 18.

Rubin, Daniel. "Image of Affirmation: Powelton Mural to Be Dedicated." *The Philadelphia Inquirer,* December 5, 1990, sec. B, pp. 1, 4.

Salisbury, Stephan. "An Artist of Eerie Vision." *The Philadelphia Inquirer,* February 1, 1985, sec. D, pp. 1, 8.

Schwabsky, Barry. "Sidney Goodman: Beyond Expressionism and Realism." *Arts Magazine,* vol. 59, no. 1 (September 1984), pp. 114–15.

————. "Sidney Goodman: Terry Dintenfass Gallery." *Artforum,* vol. 34, no. 3 (November 1995), p. 93.

Seave, Ava. "Real Art." *The Philadelphia Inquirer,* September 25, 1977, *Today* magazine, pp. 48–53.

"Sidney Goodman: Four Paintings." *The American Poetry Review,* vol. 10, no. 5 (September–October 1981), pp. 12–13.

Silverman, Andrea. "Sidney Goodman," in "Reviews." *Art News,* vol. 88, no. 6 (Summer 1989), p. 166.

"Sold Out Art." *Life,* vol. 55, no. 12 (September 20, 1963), pp. 125–29.

Sozanski, Edward J. "A Profound Commitment to Realism." *The Philadelphia Inquirer,* February 5, 1985, sec. D, p. 4.

————. "Looking Beyond Manhattan for Artists of Note." *The Philadelphia Inquirer,* December 22, 1985, sec. H, p. 16.

————. "Reagan in Art: Bucknell Show Depicts the Ex-President." *The Philadelphia Inquirer,* January 27, 1989, sec. C, pp. 1, 5.

"State of the Market." *Time,* vol. 81, no. 25 (June 21, 1963), p. 62.

Tannenbaum, Judith. "Sidney Goodman." *Arts Magazine,* vol. 51, no. 9 (May 1977), p. 35.

Taylor, Robert. "Sidney Goodman at BU: Gifted but Vulnerable." *Boston Globe,* March 28, 1982, sec. A, p. 5.

Toll, Nella. "Art Around Us." *Jewish Exponent,* vol. 146, no. 23 (December 5, 1969), p. 27.

————. "Art Around Us." *Art Paper,* vol. 1, no. 7 (April 1982), p. 6.

"Upsurge in Human Interest." *New York Herald-Tribune,* December 17, 1961, sec. 4, p. 9A.

"Visceral Realism." *American Arts Quarterly,* Spring–Summer 1987, p. 17.

Ward, John L. *American Realist Painting, 1945–1980.* Ann Arbor, 1989.

Weissman, Julian. "Sidney Goodman," in "New York Reviews." *Art News,* vol. 74, no. 5 (May 1975), pp. 100–101.

Wilson, Janet. "Sidney Goodman: 'When the Hand Touches the Canvas, That's the Real Ball Game.'" *Art News,* vol. 79, no. 3 (March 1980), pp. 74–77.

# Index of Works Illustrated